Canon

International

EOS100

U.S.A.

EOS ELAN

HOVE FOTO BOOKS Tom Maskell

In U.S.A.

the EOS 100 is known as

EOS Elan

All text, illustrations and data apply to either one of the above cameras

First English Edition Fedbruary 1992
Published by Hove Foto Books
Reprinted January 1993
Jersey Photographic Museum
Hotel de France, St. Saviour's Road, St. Helier,
Jersey JE4 8WZ

English Translation: Petra Kopp
Technical Editor: Colin Leftley
Canon Technical Advice: Graham Smith
Production Editor: Georgina Fuller
Printed by The Guernsey Press Company Limited,
Commercial Printing Division,
Guernsey, Channel Islands.

British Library Cataloguing-in-Publication Data.
A catalogue record for this book is available from the British Library

ISBN 0-906447-98-4

Worldwide Distribution:

Newpro (UK) Ltd,
Old Sawmills Road,
Faringdon, Oxon SN7 7DS
Tel: 0367 242411 FAX 0367 241124

Contents

The quiet revolution

"Congratulations on buying this fantastic camera"... Most camera instruction manuals still start this way, or in a similar vein.

Canon uses the words "Thank you for selecting a Canon EOS camera". But what sounds hackneyed, or even a little ridiculous in many cases, is quite justified in the case of the Canon EOS 100/Elan, for this camera has the makings of becoming an interesting milestone in the history of the autofocus camera. The Canon EOS 100/Elan is a camera in a new performance class, and Canon says that it will revolutionize the design of SLR cameras. This will be a 'whispering revolution', for the EOS 100/Elan is a very silent camera.

Take a close look at the Canon EOS 100/Elan and you will soon realize that it's a camera with an excess of functions. But this doesn't mean that you have to use them all, but simply that you can make use of them if you wish. Simply pick out what you actually need from the camera's outstanding specification. The programming possibilities the Canon EOS 100/Elan offers makes it easy to create a made-to-measure camera, tailored to your own needs and this book aims to help you do this. I want to give you step-by-step instructions to teach you how to make the most of the EOS 100/Elan. Starting with the preset programs that promise good shots from the outset, you will then learn to use the camera's special functions purposefully to let you turn your ideas into good shots in any situation.

Canon has realized an interesting concept with this camera. Placed in the medium price bracket, the EOS 100/Elan has features quite at home in a professional setting. A fast motordrive, extremely quiet shutter release, extensive exposure and exposure compensation programs as well as manual exposure mode and an automatic depth of field program - all these features show that the camera is designed for the committed photographer who knows how to use

The EOS 100/Elan is a photographic tool that offers plenty of scope, from a fully automatic program to manual exposure mode.

sensible automatic features, like autofocus, exposure programs and so on, but does not want to rely on automation entirely. It suits those who need sufficient control for their creativity.

This book offers ambitious photographers the necessary basic knowledge, information and tips to enable them to make the best possible use of the EOS 100/Elan in every situation to take good pictures.

Acknowledgements:

This book would not have been possible without the support of Canon. The company was kind enough to put at my disposal all necessary information and equipment.

Inside the ergonomically shaped body of the EOS 100/Elan you will find highly integrated technology and a wealth of features to satisfy even the most discerning photographer.

10

EOS 100/Elan - the camera

Canon labels the EOS 100/Elan as a 'whispering revolution'. 'Whispering' because extensive measures have been taken to muffle camera noise. The sum total of this is that the EOS 100/Elan has become noticeably quieter than any other EOS.

The most obvious speciality of the EOS 100/Elan then, is audible; or rather it isn't. During film winding the camera generates only a quarter of the noise of comparable cameras. Six different noise reduction techniques contribute to this:

1) Film winding is carried out by a belt drive whose sprockets are rounded so they engage more easily and can transfer power more effortlessly. This eliminates vibrations and the noise connected with them.

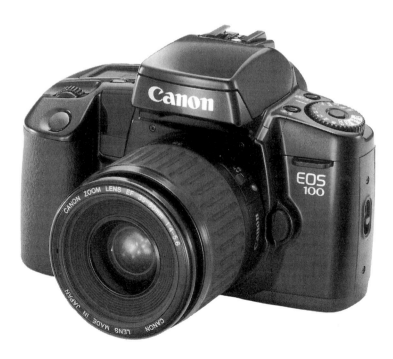

2) Rubber supports are used in three places between the film winding mechanism and the camera body in order to muffle vibration noise.

3) Acrylic foam supports muffle the camera noise in three places between the shutter and mirror cocking motor and the front plate.

4) Smooth coreless motors replace the conventional motors for film winding and for shutter and mirror cocking. These motors run more silently, causing less vibration.

5) Helicoidal cogs are used on the motor for cocking shutter and mirror. These engage more smoothly and transfer power less noisily.

6) The film advance distance is not determined by a sprocket wheel that engages with film perforations as in other cameras. Thanks to an optical detection system developed for the EOS 100/Elan, the usual ratcheting sound is eliminated.

All these measures mean that the EOS 100/Elan is a particularly silent camera. This gives most benefit when it is used with lenses that have quiet USM motors.

The following measures were employed to achieve the particularly silent operation of the EOS 100/Elan:

1) Coreless motor for film winding.

2) Film winding by means of a special belt drive system.

3) Film rewind via a belt drive system which works comparatively silently.

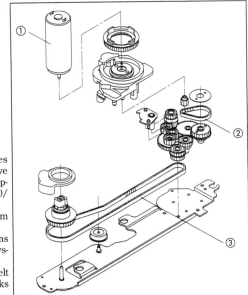

The advantages of reduced camera noise isn't only apparent when taking shots of shy animals in the wild. Thanks to its silent operation, the EOS 100/Elan is an inconspicuous machine whose camera noise is barely audible, or completely inaudible when used in livelier situations, at the funfair or during a birthday party. When talking to your subject, you can take casual portrait shots without the camera competing with you.

If you had to describe the EOS 100/Elan using a few slogans, it would sound something like this: a 35mm SLR, open aperture integral metering with six-zone SPC, evaluative metering, partial metering, centre-weighted average metering, automatic program, shutter priority, aperture priority, depth of field program...

But let's leave it there, even though there is a plenty more to add. When buying a camera, such a wealth of features is initially very impressive, you think "it can do all that!" But afterwards it can also make you give up too quickly, because you don't know how to make good use of everything. In the worst instance this may mean that only a single camera mode is used all the time - the fully automatic program.

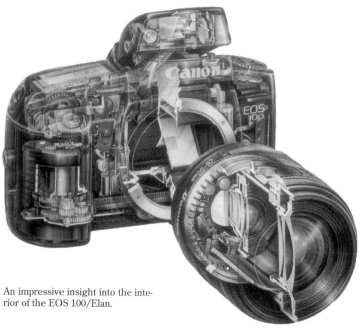

An impressive insight into the interior of the EOS 100/Elan.

This would be a shame and would mean wasting many opportunities. After all, the EOS 100/Elan offers such a multitude of interesting additional functions for purposeful picture taking. This book is one remedy for this difficulty because it will help you to find your way around the EOS 100/Elan more easily.

But in everyday use the well thought-out design of the EOS 100/Elan is far more important. The main dial above the shutter button assumes different functions, and different indicators appear on the LCD panel depending on the shooting mode selected. If program mode is selected, only aperture and shutter speed appear when the shutter button is pressed lightly. The main dial can then be used to 'shift' the program but more on this in the second chapter on photographic practice. On the other hand, if shutter priority (Tv) is selected, the panel initially shows only a shutter speed. This can be changed at any time with the electronic input dial, but the corresponding aperture is selected automatically.

Although this isn't so easy to put this into words, it is really very simple in practice. The EOS 100/Elan keeps up with your thinking, as it were, and will offer you those options that make sense in a particular situation. This means that the two central operating controls - the command dial on the left and the main electronic input dial on the right - offer easy control of, and access to, all the camera's important functions.

Tips on photographic technique

Compared to larger film formats that are measured in centimetres, the dimensions of the 35mm format are not exactly generous. On the other hand, the great success of the 35mm image has its roots in this restriction, which allows cameras to be substantially easier to handle and cheaper than their larger cousins. With such cameras a film winding speed of three frames per second is very far removed from reality. Also, the range of system accessories, from the zoom lens down to the macro lens, is unequalled in the 35mm format, offering the widest number of alternatives while remaining affordable.

Thanks to the development of new film emulsions, the disadvantages of the format have become increasingly negligible in the course of time. Kodak's Ektar colour negative film, for example, is

14

The camera's operating controls

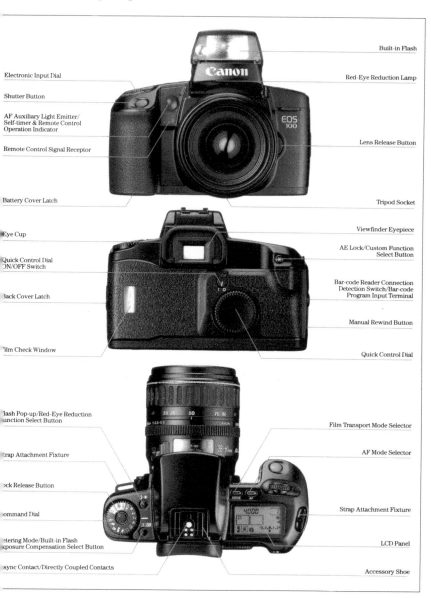

Built-in Flash

Electronic Input Dial

Red-Eye Reduction Lamp

Shutter Button

AF Auxiliary Light Emitter/
Self-timer & Remote Control
Operation Indicator

Remote Control Signal Receptor

Lens Release Button

Battery Cover Latch

Tripod Socket

Eye Cup

Viewfinder Eyepiece

Quick Control Dial
ON/OFF Switch

AE Lock/Custom Function
Select Button

Back Cover Latch

Bar-code Reader Connection
Detection Switch/Bar-code
Program Input Terminal

Manual Rewind Button

Film Check Window

Quick Control Dial

Flash Pop-up/Red-Eye Reduction
Function Select Button

Film Transport Mode Selector

Strap Attachment Fixture

AF Mode Selector

Lock Release Button

Command Dial

Strap Attachment Fixture

Metering Mode/Built-in Flash
Exposure Compensation Select Button

LCD Panel

X-sync Contact/Directly Coupled Contacts

Accessory Shoe

15

one film whose performance can hardly be fully utilized by normal lenses - it is notorious as the 'lens killer'. Other films don't lag behind in this area either - Fuji's Velvia, for example, is a very sharp slide film indeed.

Emulsions and lenses are so excellent nowadays that the 35mm format is the most suitable format in the vast majority of cases. It's also worth mentioning a veteran called Kodachrome, a development from the 1930s, which is still one of the sharpest slide films with the finest grain.

If you are looking for top class results in 35mm photography, you need careful photographic technique. Common mistakes like unsharpness become noticeable far more quickly due to the greater magnifications required compared to larger formats. It is therefore highly advisable not to simply use the reciprocal of the focal length as a minimum for handheld shots. If you want to meet the highest standards in terms of sharpness, halve this figure once more. So a lens with 100mm focal length should not be used at 1/125sec, but instead at a shutter speed of 1/250sec whenever possible. Otherwise resort to a tripod or monopod.

The reason why demands are so high in 35mm photography lies in the fact that even a medium format print of 20x25cm requires a linear magnification of roughly eight. This in turn means that every square millimetre of film has to pass on the colour, brightness and sharpness data it has stored to 57 square millimetres of paper. In other words an area of 864mm^2 (24x36mm) is enlarged to 50,000mm^2 (20x25cm). Compared to this, a 6x4.5cm negative, which represents the poorest quality medium format, will at worst have an enlargement ratio of 1:20. This becomes better with larger formats like 6x7cm.

Please note that the viewfinder image of the EOS 100/Elan only shows 90% of the subject. It was deliberately kept smaller to ensure that things set towards the edge of the frame definitely appear in the final photograph. As a result, important edge detail can still be seen when slides are mounted in frames, where the frame covers a small portion of the image edge.

Your first glance through the viewfinder eyepiece of the EOS 100/Elan reveals the brightness and brilliance of the viewfinder image. This is thanks to the excellent laser matte focusing screen. If you take off the lens and look straight into the camera, there is reflection of the matte screen in the reflex mirror. If you tilt the

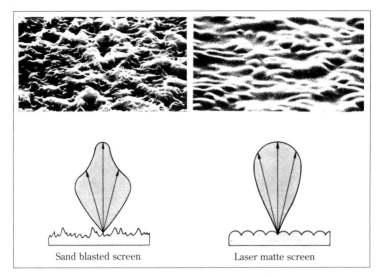

Sand blasted screen Laser matte screen

Thanks to their more even surface, laser matte screens provide higher transmission values than conventional screens produced by the sand blasting method. Viewfinder brightness and brilliance are better.

camera backwards, you can see the matte screen itself at the top, inside the camera. The screen makes the image created by the lens visible to the photographer. Canon has been using special laser matte screens for some time now and these are substantially better than conventional matte screens. They get their name from the laser finished tool moulds that are used to make them. Compared to sand blasting, this method achieves a substantially more regular surface structure. As a result, laser matte screens transmit light more efficiently than conventional matte screens. The viewfinder image becomes brighter and more brilliant.

Central command dial

This is positioned on the left-hand side of the top panel and allows the user to directly select not only one of the 11 shooting modes but also exposure control modes such as multiple exposure and automatic exposure bracketing.

This single-switch operation enables first-time EOS users to operate the camera efficiently. The command dial can be divided into two areas, the creative zone (P to Depth) and the programmed image control and image zone (green rectangle to Bar-code).

The L in the red rectangle indicates the camera's off position. The green rectangle is a fully automatic mode allowing the camera to select the shutter and aperture values for you. The camera will take into consideration the lens and focal length in use, film speed and of course the available light. The built-in flash is automatically activated when the camera requires additional lighting, not only in the dark but also when backlit situations are recognized.

In addition to the green rectangle, there are four programmed image controls or P.I.C.s: portrait, landscape, close-up and sport. These are fully automatic programs, selecting one of these modes turns the camera into one specifically geared to that particular subject. The metering, autofocus, film transport and the use or non-use of the built-in flash are all preset.

The bar-code program allows the user to fall back on professional experience in the form of the optional available bar-code book and reader. The bar-code book contains photographic examples taken by professional photographers, with the necessary exposure information contained in the bar-code underneath. This can then be transferred to the camera through the bar-code reader.

Command Dial

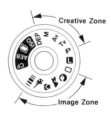

Creative Zone

P : Program AE
Tv : Shutter-priority AE
Av : Aperture-priority AE
M : Manual Exposure
DEP: Depth-of-Field AE
ISO : Film Speed Setting
▣ : Multiple Exposures
AEB: Auto Exposure Bracketing
CF : Custom Function Setting

Image Zone

□ : Full Auto
◑ : Portrait
➴▲ : Landscape
♥ : Close-up
🏃 : Sports
ⅠⅡⅢⅠ : Bar-code program

Electronic input dial

The EOS 100/Elan realizes efficient exposure control operation by using a twin dial layout. The electronic input dial can be found immediately behind the shutter button. It allows the user to change the variable settings according to the function in use, e.g. the shutter speed in shutter speed priority and manual, the aperture in aperture priority, and the combination of shutter speed and aperture value in program mode.

The electronic input dial when used in conjunction with the central command dial, allows you to select the number of multiple exposures required, the degree of exposure compensation required in the automatic exposure bracketing mode, the custom functions required to customize the camera to your specific setting and to select the correct film speed rating, when using non-DX coded film. When the electronic input dial is rotated with the metering button depressed, one of the three metering modes can be selected - evaluative, partial or centre-weighted average.

Quick control dial

This is the second dial in the EOS 100/Elan twin dial exposure control layout. It is positioned on the back cover just underneath and to the right of the viewfinder eyepiece - conveniently placed for easy access with your thumb without having to remove your eye from the viewfinder.

The quick control dial allows you to change the aperture values when using the camera manually.

When using an AE mode, exposure compensation up to +2 or -2 stops, in half-stop increments, can be made by turning this dial.

A locking switch prevents accidental use.

Flash pop-up/red-eye reduction function select button

This is one of the two buttons positioned on the left-hand side of the camera next to the central command dial. First pressure will bring

the flash head into position and second pressure will activate the red-eye reduction mode.

Metering mode/built-in flash exposure compensation select button

This is the other button positioned next to the central command dial and again serves two purposes. When used with the electronic input dial, the metering system can be selected, and with the quick control dial the desired amount of flash exposure compensation can be set in half-stop increments up to +2 or -2 stops.

Film winding mode/self-timer and remote control button

Also known as the **Drive** button, it is the blue button just in front of the LCD panel. It is used to shuttle between single shot film advance, continuous film advance (three frames per second), and self-timer/remote control mode. With the self-timer a ten-second delay shutter release is activated on full pressure of the shutter button. When using the optionally-available remote control unit, RC1, the shutter can be triggered remotely from up to 5m away from the camera.

AF mode button

This is the grey button next to the **Drive** button. It allows you to change from One-Shot focus, where the focus distance of your subject is locked, to AI Servo which is a tracking focus with predictive autofocus incorporated into the system.

This winter landscape requires an exposure compensation (+1.5EV), otherwise it would be too dark, as the exposure meter is calibrated to grey. Instead of setting exposure compensation, you could also use the bar-code reader to input a special program for white subjects into the EOS 100/Elan.

Rewind button (manual)

This is a recessed button positioned in the hand grip on the right side of the camera. It is used to rewind the film before the camera's automatic rewind system is activated, e.g. in the middle of a film or if custom function CF1 is set. It cancels the automatic rewind at the end of the film.

Bar-code receptor

This is located just above the manual rewind button. When using the optionally-available bar-code reader you have to push the bar-code reader into the bar-code receptor, so that the information can be transmitted from the reader to the camera.

AE lock/custom select button

Positioned just behind the LCD panel with an asterisk marked in the centre, this button will lock the exposure while the button is pressed, or for 6 seconds after releasing it. It is also used to activate or cancel the custom functions.

Shutter button

The basic focusing mode works on Canon's so-called **One-Shot** principle. Exposure and focus are measured and stored when the shutter button is pressed lightly. Only then can the shutter be released and the frame exposed, by pressing the button all the way down. The shutter button is locked if the autofocus cannot find a focus point.

Available light photography with (little) available light maintains the mood of the lighting, and the coarse grain of the film material provides an additional creative element. This shot required a fast fixed focal length lens. Because of the slower speed, a zoom lens would have required a shutter speed about six times slower and therefore necessitated the use of a tripod. Flash, on the other hand, would have destroyed the atmosphere.

The camera can, of course, be panned after focusing to allow you to compose. So, if you have enough time, you should let the camera focus first and then compose before you trip the shutter. On the other hand, there is only one possibility when the autofocus in set to **AI Servo** mode where the focus is continuously adjusted.

If the selector switch on the lens is set to **M** for manual focusing, you can fire when you want. But this also means that you can get unsharp shots.

Viewfinder information

Hardly any camera nowadays makes do without an LCD panel. Unfortunately, many camera manufacturers believe that it's such a good idea that the viewfinder display is left spartan. Important data can then only be seen on the body panel, when photographers really want to see comprehensive details of camera settings when looking through the viewfinder.

Happily, the viewfinder of the EOS 100/Elan leaves nothing to be desired. Thanks to its illuminated scale, easily legible in any situation, the photographer always knows what's what, without taking the eye from the viewfinder.

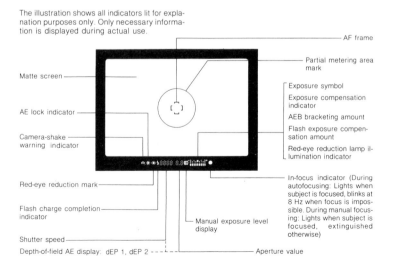

The illustration shows all indicators lit for explanation purposes only. Only necessary information is displayed during actual use.

AF frame

Partial metering area mark

Matte screen

Exposure symbol

Exposure compensation indicator

AE lock indicator

AEB bracketing amount

Flash exposure compensation amount

Camera-shake warning indicator

Red-eye reduction lamp illumination indicator

Red-eye reduction mark

In-focus indicator (During autofocusing: Lights when subject is focused, blinks at 8 Hz when focus is impossible. During manual focusing: Lights when subject is focused, extinguished otherwise)

Flash charge completion indicator

Manual exposure level display

Shutter speed

Depth-of-field AE display: dEP 1, dEP 2

Aperture value

The scale shows everything important. On the far left a small camera symbol flashes if there is a danger of camera shake and a small star next to it signals if the exposure lock is set. A flash symbol lights up if a system flash unit is switched on and ready to fire.

Current shutter speed and aperture are indicated in half-stop increments in the centre, and the small scale on the extreme right gives precise information on any selected exposure compensation, or automatic exposure bracketing (AEB) set.

The LCD panel

Look at the LCD panel on top of the camera and you'll be rewarded by more data than can be found in the viewfinder display. LCD is short for Liquid Crystal Display. One very important graphic is the battery charge indicator. The indication changes to show remaining capacity, so you can change the batteries in time. You can also check whether or not a film is loaded and, if so, tell how many frames have already been exposed. The frame counter always gives the number of the current frame that has been positioned in front of the shutter. So if the counter shows **16**, this means that 15 shots have been taken and the film has been advanced to the sixteenth

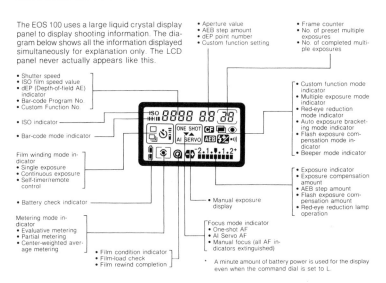

The EOS 100 uses a large liquid crystal display panel to display shooting information. The diagram below shows all the information displayed simultaneously for explanation only. The LCD panel never actually appears like this.

- Aperture value
- AEB step amount
- dEP point number
- Custom function setting

- Frame counter
- No. of preset multiple exposures
- No. of completed multiple exposures

- Shutter speed
- ISO film speed value
- dEP (Depth-of-field AE) indicator
- Bar-code Program No.
- Custom Function No.

- ISO indicator

- Bar-code mode indicator

Film winding mode indicator
- Single exposure
- Continuous exposure
- Self-timer/remote control

- Battery check indicator

Metering mode indicator
- Evaluative metering
- Partial metering
- Center-weighted average metering

- Film condition indicator
- Film-load check
- Film rewind completion

- Custom function mode indicator
- Multiple exposure mode indicator
- Red-eye reduction mode indicator
- Auto exposure bracketing mode indicator
- Flash exposure compensation mode indicator
- Beeper mode indicator

- Exposure indicator
- Exposure compensation amount
- AEB step amount
- Flash exposure compensation amount
- Red-eye reduction lamp operation

- Manual exposure display

Focus mode indicator
- One-shot AF
- AI Servo AF
- Manual focus (all AF indicators extinguished)

* A minute amount of battery power is used for the display even when the command dial is set to L.

frame, and is still waiting to be exposed. Incidentally, the frame counter is only active when a film is loaded.

The panel also shows aperture and shutter speed, and any exposure compensation selected. You can also see whether special custom functions have been programmed (the indication **CF** appears) and whether automatic exposure bracketing has been activated (the indication **AEB** lights up and the increments are marked on the small scale).

Finally, there are two inner panels. One, surrounded by a blue rule, indicates whether the motor has been programmed to single or continuous exposure mode, or set to the self-timer function. The other shows the autofocus mode set.

The bayonet

Unlike the screw threads used in the past, the bayonet mount has now become universally accepted as a fast and secure coupling between camera and lens. The reason for this is simply that it allows faster and more precise mounting of lenses. Just have a look for yourself how small the turning movement is that is needed to securely attach the lens when the red index marks are aligned - it is less than one-quarter turn. A screw attachment on the other hand

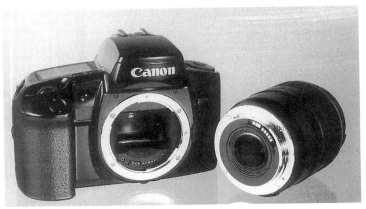

As it makes do without mechanical coupling elements, the exchange of data between the EOS 100/Elan and its lenses takes place electronically, without delay and very accurately.

would require several complete turns. To disengage the lens from the camera, press the lens release button next to the camera bayonet and turn the lens to the left before lifting it out.

In order to make all program functions available, data has to be transmitted from camera to lens, as well as the other way around. This is because, in the automatic programs, the EOS 100/Elan controls the shutter speed inside the camera, but also the diaphragm in the lens.

As the focus and aperture control motors are located in the lens, Canon can do without mechanical transmission contacts altogether. Gold-plated electronic contacts take on the transfer of data between camera and lens computer (which controls the AF and iris diaphragm motor). This is how data about the speed and focal length of a mounted lens are transmitted.

The bayonet is the most important mechanical coupling element. Camera and lens bayonet have to engage very precisely to ensure that film plane and lens are parallel. If this does not happen, the camera's self-test system will record any breakdown in communication and shut the camera off. **BC** will flash on the LCD panel

The motordrive

Setting: Press the blue **Drive** button in order to select single or continuous exposure mode.

Depending on the mode selected, the EOS 100/Elan will either fire the shutter once every time you press the shutter button, or release it continuously at a rate of up to three frames per second while shutter button is half down. Obviously if the film ends, the camera stops.

At three frames per second, the integral motordrive of the EOS 100/Elan is fairly fast. It can't be called a real high speed affair, because some manage more than ten frames per second, but it isn't a 2 fps winder either. Instead, it is a practical film advance with just the right speed for carefree photography and leaves the rapid advance lever well behind. With the integral motordrive you won't find yourself in the situation when you're just about to shoot a once-in-a-lifetime shot, only to realize that you've forgotten to cock the shutter! Beginners in particular, not in the habit of winding on

Thanks to motorized film winding, the EOS 100/Elan is always ready to shoot, and the photographer can concentrate fully on the subject in order to release the shutter at the right moment.

immediately after firing, will find that the EOS 100/Elan happily takes on this job. In sum, it's a good example of sensible camera automation.

So, an integral motordrive is a good thing - especially if it's as fast as the one in the EOS 100/Elan, which really deserves to be called a motordrive. But despite all its speed, it can't pick the right moment for the exposure, even though this is generally assumed to be the case.

The fact that this is impossible becomes clear with just a simple calculation. Let's assume we want to take a sharp shot of a sporting scene, at 1/2000sec. This means that, at a rate of three frames per second, only three two thousandths of a second will be captured - that's just a small fraction of the time elapsed. So in this example you will have captured 1/666sec. The chances of capturing the climax of the scene in such a small fraction of time is consequently extremely small.

But if this is the case, is a motor really necessary? I think it is. For a start, it is great not to have to advance the film manually after every shot. This isn't just a convenience that will suit those who lean towards idleness, but it means you don't have to take the camera from the eye between shots. It also avoids the distracting process of manually advancing the film. In this respect a motor substantially eases the problem of picking the right moment.

Secondly, motorized film winding is much faster than you - or I - could ever be. This, combined with constantly looking through the viewfinder, helps you to determine more precisely the right moment to shoot. Blindly pointing the camera doesn't achieve much, though, and you do need to practice to be able to judge precisely the time you and the camera need to turn the thought "I'm taking a shot now" into a reality by pressing the shutter button and allowing time for the mirror to flip up and for the shutter to run.

The shutter

A vertical metal focal plane shutter controls the shutter speeds. To do this, two metal curtains run from top to bottom as fast as possible. The shutter speed is determined by the distance between the two curtains. The closer they follow on from each other, the narrower the gap through which the film can be exposed. This means a fast

The shutter controls the period of time during which light can fall onto the film, and therefore determines - together with the aperture - the correct exposure.

shutter speed, up to 1/4000sec on the EOS 100/Elan is possible, where the maximum shutter speed is determined by the speed of the curtains when the gap is at its narrowest. Such a fast shutter speed is possible because, firstly the curtain runs across the narrow side of the film gate, so the distance travelled is less than with a horizontal shutter. Secondly, the slats are specially formed.

At the other extreme of the shutter speed scale, the EOS 100/Elan allows long exposures up to 30 seconds - in manual mode the camera allows any speed beyond this using in the **bulb** setting where the shutter stays open for as long as the shutter button remains pressed.

It is extremely important that the shutter runs evenly so every part of the film receives the same amount of light. The demands this imposes on shutter construction become clear when you realize that each curtain has first to reach an extremely high speed from a standing start. Then it has to travel across the film window as evenly as possible, and finally it needs to stop abruptly.

Due to the inertia of the shutter elements, a completely even speed simply cannot be achieved across this short distance, so the

The shutter speed is also important for sharpness of movement, Shutter speeds that are too slow lead to camera shake or speed blur.

width of the gap is adjusted continuously to compensate. This guarantees an absolutely even exposure. As the shutter blinds get faster and faster, which would result in underexposure, the gap is continuously widened by minute amounts in order to ensure that, overall, every part of the film receives the same amount of light.

When the shutter release process is completed, the shutter needs to be returned to its original position, so that it can start again from the beginning for the next shot. This happens immediately after the shot has been taken, at the same time as the film is advanced. Incidentally, you should be careful with the exposed shutter when loading film. The shutter curtains are extremely delicate because they must be kept as thin as possible to keep their weight low to achieve fast shutter speeds.

If the second curtain runs with a delay, the gap becomes wider and the shutter speed becomes slower. As the shutter speed slows down, it will reach the point where the gap is as wide as the film window - 24mm. From this shutter speed onwards - 1/125sec on the EOS 100/Elan - the shutter reveals the entire film window.

This speed is also the camera's X-sync speed which must be used with flash units. Because flash lights the film very briefly, if the film window is not fully revealed at this moment, only part of the film will be exposed. Slower speeds are controlled by a further time delay between the first and second curtain. At a shutter speed of 1/30sec, for example, the first curtain reveals the film window from top to bottom as fast as possible. The second curtain follows at the same speed 1/30sec later, also from top to bottom. This ensures that the parts of the film that are exposed first are also covered up again first, resulting in an even exposure of 1/30sec across the entire frame.

Having made sure that there is no film in your camera, open the back cover and examine the constructional components needed to guide the film securely. One feature you will come to appreciate very quickly is the semi-automatic film threading. Gone are the finger acrobatics needed in earlier days, when the film leader still had to be threaded onto the take-up spool. Now you just need to pull the film as far as a mark, close the back cover, and the EOS 100/Elan will do the rest for you.

But then stop and take a look around the interior of the camera. A sprung plate, the film pressure plate, is attached inside the back cover. In conjunction with the two shiny black film guide rails, which are ground particularly carefully to a level, this plate ensures that the film lies exactly flat when loaded. This is very important because buckling by as little as a few hundredths of a millimetre could mean that the picture is not in sharp focus across the whole frame.

What's missing from the EOS 100/Elan?

When examining the camera body, you will notice that there is no connection for a cable release. But this does not matter much as you can leave the integral self-timer to carry out this function. A cable release is designed to prevent vibrations on long exposures from a tripod; these vibrations, caused by pressure on the shutter button, are inevitably transferred to the camera body and tripod. The whole photographic unit will then continue to vibrate for quite a while, and in unfavourable circumstances this could cause the shot to become blurred, even at relatively fast shutter speeds like 1/8sec, despite the tripod.

When required, it is possible to use flash adapters, to connect studio flash units with cable connections to the hotshoe contact of the EOS 100/Elan.

Tip: If a long exposure is released via the self-timer, the camera can come to rest during the countdown, and the shot will not be blurred.

As you can see, the integral self-timer of the EOS 100/Elan can almost completely replace a cable release. It is therefore advisable to use the self-timer for all tripod shots when slower shutter speeds are expected.

If there is a reason why you cannot do without a cable release, Canon offers a remote controller as an accessory. This allows the camera to be released from the even greater distance of five metres.

Apart from this, the EOS 100/Elan - like many other cameras - does not have a flash cord connection. Generally this will only rarely be needed, as system flash units are attached via the central hotshoe of the camera, on the pentaprism housing. And the special system flash units do have substantial advantages and offer easy operation.

But what if you need to connect an old hammer head flash unit, or even a studio flash system using a sync cord? In such cases a small flash adapter comes to the rescue, allowing such connections without any difficulty. It is simply pushed into the hotshoe and has a central contact as well as a socket for the flash unit's cable.

In this case you lose all the system flash functions. The shutter speed has to be set to 1/125sec (or slower), and the aperture needs to be selected manually, depending on the power of the flash. But this method does allow you to attach a studio flash unit or an old flash unit you may still have.

Self-timer

Setting: Press the blue **Drive** button until the self-timer symbol appears on the LCD panel.

The self-timer is not only useful for capturing on film the photographer together with his family or friends, but also, as you have just read, for a vibration-free shutter release. This is important in the macro range, when you are using long bellows extensions and the camera is not firmly mounted. But switching on the self-timer to prevent any vibration can also be useful in the long exposure range, when you are using tripods that are not very sturdy.

One very useful function can be selected via the custom function CF 7: if you key in **1** at this function setting, the mirror is flipped up 10 seconds before the exposure.

EOS 100/Elan QD

Whilst its functions are otherwise the same as those of the EOS 100/Elan, the EOS 100/Elan QD is equipped with a special databack, which allows the current date or time to be imprinted onto the lower right-hand side of the photograph. QD is short for Quartz Date and refers to the integral digital automatic calendar and quartz control clock system, which produces a high degree of precision. Quartz crystals vibrate at a certain, very exact frequency, given in Hertz. 10,000 to 20,000 oscillations per second are typical for technical quartz crystals. These oscillations are counted via an electronic

Month/Day/Year

Day/Hour/Minute

Year/Month/Day

Day/Month/Year

The data indication and imprint function of the EOS 100/Elan QD (with databack) is achieved with a digital LCD display. The sequence can be selected freely.

34

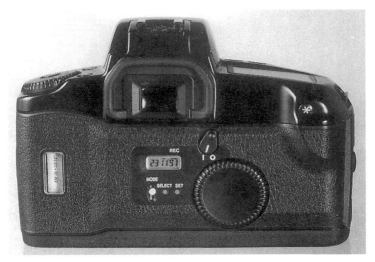

The EOS 100/Elan QD has a permanently attached databack with an automatic calendar and clock for imprinting the date or time.

circuit in the databack. With a quartz crystal vibrating at 20 Megahertz, a full second is only reached when the circuit has counted to 20,000! This is the reason for the great precision of quartz watches. The deviation is no more than 90 seconds per month - a figure mechanical watches can exceed in one day.

With the databack, day/month/year can be imprinted on the photograph in any sequence - or the day and time instead. This is just as well and convenient, too, as not everybody wants to decode the indication '10 12 88'. No, it doesn't mean 10 December 1988, it's the American way of writing it: October 12, 1988. And even if the photographer could get used to this unfamiliar format, the whole point of the date imprint is to tell all viewers at a glance when a shot was taken. So wrong interpretations would already be preprogrammed as we will just assume that the date is given in the format we are familiar with. Luckily we can decide on '12 10 88' on the EOS 100/Elan QD, so everybody will know straight away what's what.

The indication and imprint of the data is achieved via digital LCD indicators. The imprint function can, of course, be switched off, and the databack is really very easy to use. Use the **SELECT** button to choose the digit to be changed and input the desired value using the **SET** button. Date and time can be set in this way. The sequence of

day, month and year is selected with the **MODE** button, which is also used to switch to the day and time indication. The calendar in the EOS 100/Elan QD is already preprogrammed for the period from 1987 to 2019, and it takes into account the different length of months as well as leap years.

The usefulness of such a databack depends on personal preferences. With many slide films that come back framed from the laboratory the current date is already noted on the frame. This means that the month and year can be clearly established even after a long time, unless you are one of those people who load a film just before Christmas and don't take it out until the same date the following year. Still, if you're only interested in a rough date and mainly use slide film, you can probably save yourself the expense of the databack. It seems most useful to me with negative film, as the exact date of the photograph will appear on every print. This means that even years later you will be able to see straight away exactly when a shot was taken. The time imprint, on the other hand, can be useful on occasions when the date isn't easily forgotten like weddings, and birthdays. In such situations the continuous imprint of the current time can document the chronological sequence of an event.

Photographic practice 1 -
gaining good, simple photographs with the EOS 100/Elan

In this chapter you will find out how to get the camera ready to shoot, how to handle the EOS 100/Elan quickly and without problems, and how to use the integral programs for your photography without a lot of technical hoo-ha. It is not only a practical chapter on the EOS 100/Elan for photographic beginners, but is also intended for experienced photographers who want to devote themselves to technologically free photography.

Power supply

In order to be able to carry out all its functions, the EOS 100/Elan does not just house loads of microchips and plenty of 'intelligence' in the form of programs, it also contains quite a few motors to get things going. Firstly, each lens contains two motors - more on this under the heading 'autofocus' in a moment. Another motor draws the film from the cassette as soon as it is loaded, and it also pulls the exposed photographs back into the cassette frame by frame, using a belt drive.

In order for all of this to function reliably, battery power is required. Don't get confused or let somebody pull your leg and ask about the mechanical shutter speed of your EOS model. This trick question is most likely only asked to clarify whether the camera will function without batteries. It doesn't. But that doesn't matter a bit.

When, several years ago, the integral exposure metering system of the first automatic cameras became dependent on power supply, the shutter speed also quickly came to be controlled electronically and dependent on a power source. But there were good reasons for this, as electronic shutter speed control is far more precise than any mechanical solution could ever be. But the old guard were worried about suddenly having to ensure they always had a functioning battery with them. The advantages of automatic exposure control and precise shutter speed control did not hold much sway. So a

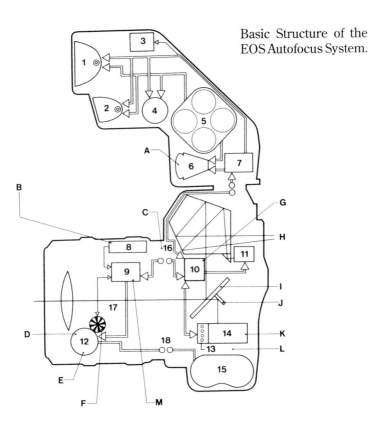

Basic Structure of the EOS Autofocus System.

1. Flash reflector
2. Infrared metering flash
3. LCD panel
4. Zoom reflector motor
5. Batteries
6. Infrared metering flash for AF
7. Flash microprocessor
8. Zoom information
9. Lens microprocessor
10. Main microprocessor
11. Display
12. AFD or USM
13. BASIS
14. AF optical system
15. Battery
16. Electronic connection for data transfer and power supply
17. Lens position information
18. Power supply

A. Lights for dark, low contrast subjects
B. Focal length information (zoom code)
C. Electronic mount
D. Lens drive motor
E. Ultrasonic lens drive motor
F. Impulse disk (for drive measurement)
G. AF ranging calculation
H. Display of ranging results
I. Full-surface half mirror
J. Auxiliary mirror
K. AF ranging unit
L. AF line sensor
M. Data transfer and lens control

'mechanical' shutter speed had to be found, which would function at all times, under any circumstances.

With the EOS 100/Elan a lot more than just the shutter control depends on the power supply. There is, for example, film winding and aperture control - so nothing can happen without a battery, which is no disadvantage at all. The benefit of a single fixed shutter speed is questionable anyway when the important exposure metering function has ceased to work. Nobody demands that their car should still have the old hand crank, just in case the car battery goes flat. We know what to do. With the EOS 100/Elan it's even easier to be safe. For a few pennies your photographic dealer will sell you the best power insurance policy imaginable, in the shape of a spare battery. And with this everything will once again function perfectly, as it is supposed to. Isn't that better than a mechanical shutter speed?

> **Tip:** A spare battery is indispensable with the EOS 100/Elan. If it is kept in the fridge, or better still the freezer (or freezer compartment), you can reduce the self-discharge of the battery to a minimum. It will then be as good as new when you need to use it.

With the EOS 100/Elan, a single battery is sufficient for all functions. It supplies the microprocessors and controls the motors in camera and lens. You need to use a high-quality 2CR5 lithium battery, which is inserted in the bottom right-hand side of the camera base. The battery's capacity is enough for approximately 40 films, based on the assumption that the small integral flash unit is used for 30% of the shots. This is quite a lot in any case, and a battery should last most people more than a year.

Choosing suitable film

Colour slide or colour negative film - which is better? Neither slide nor negative film is better than the other when it comes to being suitable always and everywhere. Every type of film has its advantages. There's hardly ever an easy answer to the question of whether slide or negative film should be used. It would be useful to have a 'hybrid', and a few years ago there was indeed a film that

could be developed either as a slide or a negative film. Unfortunately its lack of quality meant it never became a success, so we simply have to ask ourselves before we load a film, "Which one should I use?".

Let's start with the things they have in common. One particularly important point is the film speed, which determines the grain and sharpness. The photographer has to decide which parameters are the most important, and load up with a suitable film accordingly. If a sharp result with fine grain is important, then you'll load a slow film, around ISO 50/18°, and use a tripod if there is insufficient light. On the other hand, if handheld photography is your prime concern, then you'll need to choose a fast film from ISO 400/27° onwards to gain fast shutter speeds, and simply put up with the coarser grain. But in most cases you'll settle for a compromise and use films of around ISO 100/21° which still have fine grain and are sharp, while being sufficiently fast to allow handheld shots most of the time.

In this context it's a good idea to buy a few films in the slow, medium and fast categories in order to gain first-hand experience

Your choice of film will depend on the intended application. Photographing objects, for example, usually requires the reproduction of the finest details, and a low-speed film (ISO 50/18°) will be suitable.

of grain, resolution and their various applications. It's best to go for a set each of colour negative and colour slide emulsion, in order to get to know the different nuances and possibilities of the films.

> **Tip:** Films are best stored at low temperatures as they will keep better that way. The fridge is sufficient for a few days, but the freezer or freezer compartment of the fridge are preferable for longer periods. The film needs time to acclimatize: two to three hours if it has been in the fridge, overnight if it's out of the freezer.

If exposure were the only concern, the whole thing would be simple: colour negative film would be the only answer, as it has a very wide exposure latitude compared to slide film. Exposure metering is therefore not as vital with a colour negative film as it is with a slide film, but it's by no means unimportant. Here, too, optimum results can only be achieved with careful exposure but if in doubt, go for a slight overexposure. The old maxim 'expose for the shadows' still applies to colour negative film. When the shadows

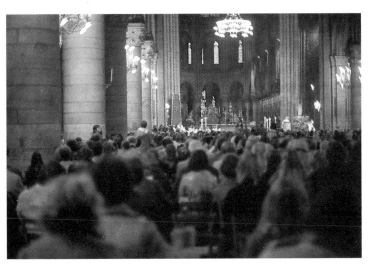

High-speed films are predominantly used for handheld photography in low light. But the visible grain can also be used consciously as a creative tool.

41

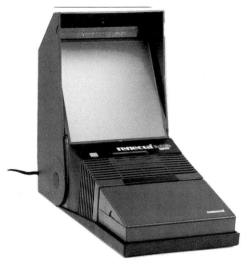

Slide monitors offer the opportunity to examine slides quickly, without the need for darkened rooms.

are metered, the exposure given is more generous, leading to better tones in the negative, which can be enlarged without difficulty.

Modern colour negative films have such a wide exposure latitude that identical films can easily be exposed at different speeds, without the need for special processing techniques. To gain your own experience of this, over- and underexpose a test film making full use of the entire aperture range offered by the lens. Choose a subject with plenty of contrast because this quickly shows any losses of detail in highlight and shadow areas. Using your results, you can decide for yourself which you still find acceptable - you'll be surprised by the immense exposure latitude. Colour negative film reacts to overexposure with finer grain, but when underexposing be prepared for an increase in the grain size.

Landscape shots live on light and colour moods, and you can discover new aspects as the seasons change. If you have a lot of sky in the shot you should use the exposure lock function (metering the foreground).

Colour slide films require very precise exposure metering because they have very narrow exposure latitude. Even on subjects with a low contrast of 1:125 (six aperture stops) you will get a maximum latitude of just over one aperture stop. On high-contrast subjects, or with imprecise exposure metering, parts of the image will no longer show any detail and only appear black or transparent. The shadows 'block up' and highlights 'burn out'. As transparent parts look unattractive in the slide, while a lack of detail in shadow regions is more acceptable, slide film should be metered 'from the highlights'. That means that, if in doubt, it is better to err towards underexposure.

Special emulsions are required for slide photography in artificial light, as daylight film gives a noticeable red-yellow cast under tungsten light. This is why there are special slide films for artificial light which, when used with tungsten light with its colour temperature of only about 3200K, reproduce colours that match what we see with our eyes.

With negative material this differentiation is unnecessary as the colour balance is adjusted by filters during the enlargement process. Professional colour negative films are sometimes divided into type L (long) and S (short). This is less to do with the colour sensitization than with the reciprocity characteristics of the emulsions. Type L is designed for shutter speeds slower than about 1/30sec (exact details in product information sheet), whereas type S is optimized for fast shutter speeds. When you are photographing with slow shutter speeds, you should always select type S, regardless of whether you're shooting in daylight or artificial light.

When it comes to the different brands, the only thing to say is this: with negative film a good processing lab is more important than the film manufacturer - all branded films are good. The lab has the greatest influence on the quality of your shots. On the other hand, with slide films there are distinct differences in their colour rendition. The quality is equally high, but one brand may have a greater tendency towards blue (Ektachrome), another towards neutral (Agfachrome), and a third is known for its rich colours (Fujichrome).

When you're on the move it's not just the grand perspectives and landscapes which are of interest. You should also watch out for subjects at the roadside, which can often yield good shots.

The main characteristic of negative film is its great exposure latitude, which ensures good shots even if the exposure has not been metered completely accurately.

Slide film has to be exposed precisely if the results are to be right - if they are, nothing will match the brilliance of slide projection.

Although slide film has so far only scored negative points, it comes into its own when you start judging the photographic results. Developed slide film offers the advantage of immediate viewing, whereas negative film only produces a finished photograph after the necessary enlargement process. When you have the developed slide film, you can immediately check the quality of the shots. A good x8 or x10 magnifying glass and a light box will be a great help in this. The best slides can then be projected, and there is no cheaper or more brilliant way of presenting your photographs as enlargements. On the other hand slides offer fewer possibilities of manipulating the shot once it's developed. If projected, there are practically no possibilities for correction and you can't do anything if exposure or composition are wrong. Even if you have prints made from your slides, only composition can be corrected, so if the exposure is wrong very little can be salvaged.

Not so with the colour negative, as it is intended to be printed. This is the reason for the orange masking, which helps to help eliminate the unwanted characteristics of the dyes in the film and so improve colour rendering. With colour negatives the quality of the pictures is greatly dependent on the processing lab producing the prints. This is because it is the lab that determines the final colour balance by means of filtering, the choice of paper, the continuity of lab processes, cleanliness and so forth. And beginners in particular will hardly be able to 'read' a colour negative in order to decide whether any mistakes are down themselves or to the processing in the lab. If you think your shots ought to look better, why not take a few selected negatives to different labs to see what they make of them. Or complain. 'Wrong colours' are only a fault on the negative in the very rarest of cases - it's almost always the lab's fault. But a good lab will be able to do sectional enlargements, make specific colour corrections, adjust exposure, and offer a choice of many different paper surfaces.

Incidentally, instead of going for an expensive sectional enlargement it is often cheaper to order a larger print, have the entire negative enlarged and then cut out the desired image section yourself afterwards.

Unlike negatives, which are designed for enlargement, a slide is intended for projection. It therefore has a high contrast of 1:1000 and more, so that it appears brilliant when projected. Photographic paper, on the other hand, has a far narrower contrast range -

depending on the surface of the paper, only 1:30 on matte surfaces, up to 1:50 with high-gloss surfaces. So, if a slide is enlarged on paper, you have to be prepared for shadows blocking up, for burnt-out highlights, and hence a lower luminosity.

In principle it would be possible to choose paper material with soft gradation, but this would lead to a flat-looking picture with washed-out colours. Reversal paper which lets you print slides directly always offers a compromise between achieving good colour saturation on the one hand, and sufficient contrast on the other. But if the slides don't have too much contrast, you can get good enlargements although sadly slides that impress you with their brilliance, fine colour rendering and tonality when projected often produce disappointing results after being enlarged.

Hybrid printer systems, which combine conventional chemical processes and electronic image processing, are one attempt to improve the quality of prints from slides. The slide is 'read' by a scanner and converted into electronic signals. These signals can now be reproduced on a monitor, and be optimized and fine-tuned using mathematical calculations. By means of a cathode ray tube the processed electronic image is re-converted into an optical image and then exposed onto photographic paper. Using this process, the result can easily be manipulated so that it can be exposed onto inexpensive, and easily processed colour negative paper. The transition from positive to negative poses no problem for the computer, and takes place before the exposure is made. Such equipment is, of course, only suitable for a large lab - but perhaps you'll find one that has such a hybrid system. Expect prints from slide prints to be substantially improved using this system. So despite the former weak points of slides - prints from slides - promising solutions are now emerging.

Tip: When selecting slides for paper prints, don't do it by projecting them. A paper print can't even get close to the high contrast range possible with projection. Hold the slide in front of an evenly lit sheet of white paper. This way you can judge much better how the slide will look as a paper print.

In summary, the following points are in favour of colour negative film: it usually has a wide exposure latitude and offers cheap and mostly good prints, which theoretically are better than those made

from slides. The main disadvantage is the fact that it is not possible to make a definitive evaluation of the negatives - you have to take the colours in the picture as they come. Because evaluation is difficult, the whole film is usually printed, even though a few negatives might be enough. But if you take shots mainly to get prints, you will be well served by a colour negative film.

Slides, on the other hand, demand precise exposure, and cheap prints are rarely satisfactory. But on the other hand the slide is ready as soon as the film is developed, and is very easy to evaluate. This can also be an advantage when prints are to be produced - it is easy to complain about bad prints when you can show the photographic dealer the original slide where all the colours are perfect. Also, usually only successful slides will be taken for enlargement. Keen photographers who get through a lot of film will therefore find slide material more economical. Finally, slide film is of course indispensable if your shots are intended for projection.

Film loading

You'll realize that the days of complicated fiddling with film transport are finally over when you load your first film into the EOS 100/ Elan. All you have to do is pull the film to the orange index and close the back cover. As soon as you switch the camera on, the EOS 100/ Elan will then thread the film all by itself.

In order to ensure secure threading, the film leader should be pulled out only just far enough, and you should make sure that the film strip comes to rest exactly along the film track. The motor starts when the back cover is closed and winds the film to the first frame. It doesn't matter if the camera is switched off when you're changing film because the film is advanced as soon as you switch on.

If the camera cannot thread the film, the film cassette symbol on the data panel will flash, and nothing will happen until you either take out the cassette completely, or re-position the film leader so that the film can be correctly advanced.

When loading the film, the EOS 100/Elan also sets the film speed automatically, important for correct exposure metering. Most film cassettes come marked with a black and silver pattern like a chessboard, which contains coded data about the speed of the film

Contacts inside the camera body read the pattern on the film cassette, registering the film speed, which is then set automatically by the EOS 100/Elan.

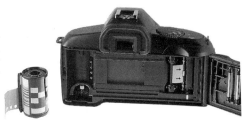

- its so called DX code. The EOS 100/Elan reads this code via contacts in the camera body and therefore recognizes the speed of the loaded film over a range from ISO 25/15° to ISO 5000/38°.

You can change these values at any time - simply set the command dial to the **ISO** setting and input the desired new speed.

On the back of the EOS 100/Elan you will see the film check window. This allows you not just to see whether you have loaded a film at all, but most film cassettes have their brand and speed printed in small letters at this position. So even if you are forgetful, you can always check what film is loaded.

The film advance distance is not determined mechanically with the EOS 100/Elan, but is detected optically, using the holes of the film perforation. Unaffected by mechanical tolerances, the film is thus advanced precisely and carefully. You can see the results of this technology by comparing a film strip exposed in the EOS 100/Elan with one from a mechanical camera. Only top-quality cameras will provide equally accurate film advance, with such precise distances between the shots.

The camera automatically rewinds the film at the end. As soon as the film has been rewound, the cassette symbol on the data panel once again starts flashing. Automatic film rewind, though, means that only the number of frames given on the film is exposed, no more. The extra two or three frames that are usually available are lost because the camera recognizes the film length from the DX code, and relentlessly rewinds as soon as this number is reached. But this is a small price to pay for the advantages of DX coding. If ever you want to rewind the film early, you only need to press the small button on the right of the body.

If you load an uncoded film, the **ISO** indicator will flash permanently, even if you have correctly selected the ISO value - this is a permanent reminder that there is no DX coding. You can select speeds between ISO 6/9° and ISO 6400/39° and the camera will assume a maximum of 36 frames, even with uncoded films.

When the EOS 100/Elan recognizes the end of the film - or if the manual rewind button is pressed - it will rewind the film into the cassette completely. This does not need to concern us as long as we take the film to be processed. If you want to develop it yourself, you will need either a film cassette opener or a film tip retriever, which pulls the film leader back out of the cassette.

If you want to keep a partially exposed film so you can use it up later, it is best for safety reasons to advance the film by another frame or two. To do this, set the camera to manual mode, select the fastest shutter speed and smallest aperture and release the necessary shots, with the lens cap on and in the shade.

Sophisticated evaluative metering

Setting: Press the button on the bottom right of the command dial and turn the main dial until the rectangular symbol with a circle and dot appears on the LCD panel.

Reliable exposure metering is the basic requirement for the success of every automatic program, however sophisticated. The automatic program simply converts the information on lighting conditions, determined by the exposure metering system, into an aperture/ shutter speed combination to suit the situation. It does not change the quantity of the exposure in any way. The amount of light actually reaching the film is consequently not altered by the automatic program, its settings are optimized by picking out the most suitable combination of aperture and shutter speed.

If the exposure measurement is wrong, the automatic program won't come to the rescue - the shot will still be too bright or too dark. In order to provide as reliable a measurement as possible, Canon uses evaluative metering employing six image zones. The view-finder image is divided into six separate parts.

The centre of the viewfinder is more strongly weighted, and as you know the EOS 100/Elan locks both focus and exposure

In evaluative metering mode the viewfinder image is divided into six separate zones. A comparison of the different brightnesses of the image centre, the central ring zone and the image edges provides information on the subject size and the conditions in the surrounding area. Differences in reflectance of the subject are also registered, and the required exposure is determined accordingly.

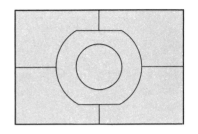

measurement when the shutter button is pressed half-way. As the autofocus frame is also located exactly in the centre of the viewfinder, this guarantees that the main subject is weighted particularly strongly when the exposure is determined.

Based on the metering results of the separate zones, the electronic system then evaluates the contrast and compares this with data stored in its memory. This analysis determines whether the subject has particularly high contrast, whether there is backlighting, whether fill-in flash is required, whether a flash exposure is necessary, and so on. The required aperture/shutter speed combination is then determined, and a connected flash unit may be fired as fill-in or main light. This evaluative metering system works very reliably, and there is hardly any light situation the EOS 100/Elan cannot cope with.

This also shows how modern technology has enabled many years of photographic experience to be converted into electronic impulses. It's the same with the camera shake warning of the EOS 100/Elan, which varies according to the selected focal length.

The first electronic light meters were designed just to meter the light, and provide results for the photographer to interpret. He had to decide how the result needed to be assessed in any given situation. The EOS 100/Elan now takes on this assessment, and so saves the photographer yet another piece of mental ballast. You can be sure that the camera will 'think of' and 'consider' whatever is necessary, usually no less competently than you.

At a glance:

- Focusing and exposure metering are coupled. The centre of focus is also more strongly weighted in determining the exposure.

- The viewfinder image is divided into six zones and analysed in order to achieve as exact an exposure as possible. This works fairly reliably even in difficult lighting conditions.

Evaluative metering delivers good exposure results in the majority of situations - but you shouldn't rely on it completely. In complicated light conditions partial metering can produce results that can be determined accurately in advance.

Easy shooting with the 'green program'

Setting: Set the command dial to the green rectangle.

Right, by now your EOS 100/Elan should be ready to take the first photographs. For your first shots, please select the 'green program', marked by a green rectangle on the command dial. By doing this you are switching to a more or less intelligent fully automatic program which gives you no option of intervention. It's not an 'idiot's' program, but a reassuring one in situations when things are hectic and you consciously want to prevent yourself from making mistakes. It is, as it were, the 'compact camera setting' that enables even completely inexperienced photographers to take good shots in most situations. In conjunction with evaluative metering - which is automatically selected and analyses the subject brightness - you can assume that this program will provide satisfactory results in 90% of cases.

The green program should be used whenever you want to shoot different subjects with as little complication as possible.

The EOS 100/Elan will now 'think' for you - selecting aperture and shutter speed, switching on the flash unit if necessary and taking care of all other parameters, such as film winding mode (single exposure), focusing etc. It selects standard values, ignoring any values you may have preselected. If, for example, you have switched off the warning beep it makes no difference - in the 'green program' it is re-activated and beeps when the autofocus has found the focus.

In low light or backlight (dark image centre in front of a bright background) the small flash unit is immediately switched on. If it is bright enough to take the shot without flash and without any danger of camera shake, the program will determine aperture and shutter speed, depending on the current focal length. It first determines whether the shutter speed is fast enough to allow shake-free shots, then stops down the aperture. From then on, if it is getting brighter, aperture and shutter speed change in step.

What is so special about this option is that the EOS 100/Elan processes a large amount of data to do this. It determines focal

length and maximum aperture, and uses these to set the optimum exposure value. The exposure program is optimized up to five times if the focal length is adjusted.

It might seem as if the automatic program is the epitome of the perfect program. But the camera setting can be changed - for good reasons. Apart from the automatic program, the EOS 100/Elan also offers shutter and aperture priority, and it can even be switched to fully manual mode. This enables you to set things yourself to precisely suit your photographic requirements.

'Green program' at a glance:
- Any programmed custom functions (CF) are deactivated.
- Single exposure mode.
- Evaluative metering.
- Automatic flash in darkness and backlight.
- No user intervention possible.

Image zone shooting modes for special photographic situations

Setting: Set command dial to the relevant symbol (head, mountain, flower, sportsman, bar-code).

The image zone shooting modes designed for special situations more specifically suit particular subjects than the green standard program. The portrait program, for example, labelled with a stylized girl's head, is of course designed for portraits. This means that it should be used with a moderate telephoto focal length - approximately 80mm to 135mm. It is optimized for those focal lengths, which are usually ideal for portraits.

As the program will select as large an aperture as possible, it is advisable to pay particular attention to focusing. The most important and most expressive elements of a portrait are the eyes, so you should always focus on the eyes. First lock the focus on the eye before composing. If you are taking a whole series of shots it may be wise to switch to manual focus and, if necessary, adjust the focus manually. This is because, having composed, the eyes will only rarely fall perfectly onto the autofocus frame.

The portrait program delivers expressive portraits in front of an unsharp background.

Portrait program at a glance:
- Any programmed custom functions (CF) are deactivated.
- Continuous exposure mode.
- Evaluative metering.
- One-Shot autofocus.
- Automatic flash.
- No user intervention possible.

The landscape program prefers particularly narrow apertures for the sake of depth of field. As soon as the shutter speed has reached shake-free territory (the reciprocal of the focal length), the program starts to stop down the aperture.

You can increase the program's tendency towards narrow apertures and great depth of field by using wide-angle lenses.

Landscape program at a glance:
- All programmed custom functions (CF) are deactivated.
- Single exposure mode.
- Evaluative metering.
- One-Shot autofocus.
- No automatic flash.
- No user intervention possible.

Great depth of field is usually desirable for landscape shots - the landscape program of the EOS 100/Elan sets priorities accordingly.

Close-up shots can be achieved without any problems, thanks to the right program.

The close-up program does not select apertures wider than f/5.6, preferring narrower ones wherever possible. This is because the depth of field is drastically reduced when shooting close-up. As the subject is usually be found in the centre of the frame, the program selects partial exposure metering, shown as a circle in the viewfinder. The exposure will only be right if this contains approximately medium bright subjects. If a subject is particularly bright or dark (a white or dark red blossom, for example), incorrect exposures may occur, which can have particularly serious effects when using slide film, with narrow exposure latitude.

But it is still a useful program for occasional shots in the macro range. Everybody should have a go at this type of photography, and since almost all EF zooms have a macro setting, this is now easy. However, keen photographers will not only acquire a special macro lens, but also read the chapter *Photographic practice 2* attentively, in order to make conscious use of the possibilities of the EOS 100/ Elan in this area.

Ultrasonic lenses of the second generation can, incidentally, feed the point of focus back to the camera, which in turn can then calculate the reproduction ratio (using the subject distance and focal length) and optimize the focus and depth of field.

The sports program prefers fast shutter speeds for sharp shots of fast-moving subjects - it is therefore suitable for all subjects with a lot of action.

Close-up program at a glance:
- All programmed custom functions (CF) are deactivated.
- Single exposure mode.
- Partial metering.
- One-Shot autofocus.
- Automatic flash.
- User intervention not possible.

 Finally, the sports program is designed for moving subjects and consequently prefers fast shutter speeds. Don't be limited or confused by the term 'sports program' as it's a handy option whenever things are happening. Young children, for example, can be quite lively, and with predictive autofocus you should always be on the ball.

Sports program at a glance:
- All programmed custom functions (CF) are deactivated.
- Continuous exposure mode.
- Evaluative metering.
- Predictive autofocus.
- No automatic flash.
- User intervention not possible.

Bar-code program

And if all this isn't enough for you, but you still don't want to switch to the more 'complicated' automatic programs such as aperture or shutter priority, then you can use the bar-code program to access even more precise program controls from a small book. Even

The bar-code reader, available as an accessory, is supplied with a bar-code book which contains different subject situations that can be programmed into the camera.

complicated exposures are possible if the appropriate program is read from the bar-code book and transmitted to the EOS 100/Elan.

Unlike earlier EOS cameras, which only allowed one bar-code program, up to five different programs can be input into the EOS 100/Elan - although these then overwrite the four image zone shooting modes (portrait, landscape, macro and sports). A special 'Clear' program from the bar-code book allows the subject image zone shooting modes to be reactivated at any time.

You will need the bar-code reader, the bar-code book and, of course, the EOS 100/Elan. Look in the book, select the desired program, by referring to an example shot and a short description with tips and symbols to help you.

Scan the bar-code with the bar-code reader - you will hear a beep tone if the code has been scanned correctly. Within ten seconds press the bar-code reader against the bar-code receptor on the left-hand side of the EOS 100/Elan in order to be able to transmit the program. But also take note that the bar-code or one of the image zone shooting modes must be preselected on the command dial.

The parameters transmitted in this way set the following functions: autofocus mode, exposure metering mode, film winding mode, exposure control - with apertures or shutter speeds in some instances permanently preselected. In some cases the aperture and shutter speed are preselected so that the exposure is only right if the subject corresponds exactly to that in the bar-code book.

What you think of this program option in the end is up to you, and this is best achieved by a little experimentation. But it is an option for the inexperienced photographer wanting to tackle more difficult exposure situations with a guaranteed measure of success.

The Canon autofocus system

Unlike many other camera manufacturers, Canon decided on an autofocus solution where the focusing motor is located in the lens rather than the camera. The disadvantages of this are that every lens needs its own motor, which costs money, and additional components make the lenses larger and heavier.

However, Canon believes that these disadvantages are outweighed by the advantages. A mechanical coupling between camera and lens to drive the focusing mechanism is rendered superfluous so it is possible to leave all the necessary mechanics in the lens. In rival systems the motor is tucked into the camera body where it controls the lens by a drive shaft. With the Canon system two motors within the lens control the focusing distance on the one hand, and the aperture on the other. The exchange of data is carried out via gold-plated contacts not subject to corrosion. This is why the motor can be tailor-made for each lens, and placed exactly where it is needed to move elements. Its power is also direct and there is no transmission loss. Unlike a motor within the camera that has to suit all lenses, the lens motor can be optimized to suit the requirements of each lens. This is a factor that Canon exploits to the full - there are now three different types of motor.

The first of these is the AFD (Arc-Form-Drive). The unusual arched form, which gave the motor its name, precisely follows the cross-section of the lens. This has made it possible to design small lenses, even though the motors are accommodated in the lens.

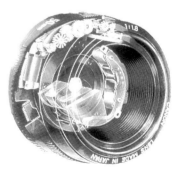

The technology of the autofocus system requires the most up-to-date computer technology in the smallest space. This complex technology can be seen in this view of an EF lens.

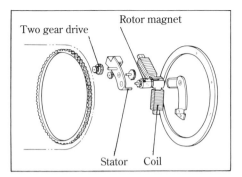

Two gear drive
Rotor magnet
Stator Coil

The arc motor allows the design of compact lenses. As the motor is located in the lens, it (and the engine) can be matched particularly well to the requirements of each lens.

Rotor Vibrator
Piezoelectrical Element
Damper Support Ring
Leaf Spring

Resonant Frequency

Piezoelectrical Elements

The USM motor is set into motion by ultrasonic waves. It is particularly silent and its simple construction means that it is not susceptible to faults.

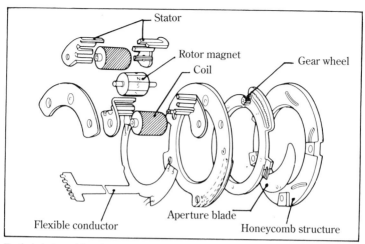

Exploded view of the electromagnetic aperture control system EMD.

Microprocessors in the EOS system

Microprocessor	Function
Main microprocessor	control of autofocus, exposure anf function sequence
Lens microprocessor	data transfer and EMD/AFD motor control
Speedlite microprocessor	data transfer and zoom reflector control
Technical Back microprocessor	data transfer, data storage and camera function control
Control Motors	
Motor M-1	film transport
Motor M-2	shutter/mirror functions and film rewinding
Motor AFD	lens focusing (arch motor)
Motor USM	lens aperture control (ultrasonic motor)
Motor Zoom	flash reflector-zoom mode (automatic flash angle control)
Shutter magnet (2)	exposure time control

BASIS - the sensor that is at the centre of the EOS 100/Elan autofocus system. Integrated amplifier circuits ensure reliable evaluation of the signal.

The bayonet is the only mechanical connection between camera and lens; all data is transmitted electronically before it is converted into movement. This non-mechanical control system has big advantages, which also apply to the second new motor - the USM motor.

'USM' is short for 'Ultra Sonic Motor'. This new type of motor has none of the mechanical parts of conventional motors. It is extremely fast and almost inaudible in operation and is popular with animal photographers. Another advantage is that no button on the lens is needed to switch to manual focusing. Manual fine-focusing is possible at any time.

The first USM motors were very sophisticated and expensive to produce, which is why they were only available in the best lenses. But Canon has now introduced the second generation USM, which is smaller and less expensive, and many EF lenses are now equipped with USM motors.

Finally, a third variant is a motor which is used for fast, linear, internal focusing by moving only certain internal lens elements. In combination with new materials and simplified lens settings, this has made it possible to develop very inexpensive, lightweight lenses for the amateur market, without compromising in quality. It

This shot has a very unusual colour atmosphere which is actually a "fault": the shot was taken on artificial light slide film in daylight.

can be found, for example in the EF 35-80mm,f/4.0-5.6 and EF 80-200mm,f/4.5-5.6 zoom lenses.

Apart from the different motors which carry out the focusing, each lens has a second small motor for controlling the aperture. 'EMD' is the electromagnetic aperture control system in every EOS lens. It controls the iris diaphragm to within one-eighth of a stop of the value calculated by the automatic program.

In order to make automatic focusing possible, the EOS 100/Elan houses a complete micro-computer. It converts analogue signals into digital ones, reads sensors, controls motors and carries out measurements. The data gained in this way is processed in many different ways, and converted into the appropriate action. This could be a motor movement which focuses the lens or a flashing indicator in the shape of a small green 'camera' in the viewfinder, if there is a danger of camera shake.

TTL-SIR and BASIS are the key terms in automatic focusing. The abbreviation TTL-SIR describes a method of metering through the lens and evaluating two images - Through The Lens - Secondary Image Registration. With this method, also known as phase comparison, two partial images of the autofocus frame are projected onto the BASIS sensor (Base Stored Image Sensor). Depending on how much the image is in focus, these partial images will be either more or less out of alignment. BASIS registers this analogue signal and feeds it into the microprocessor as digital data. The microprocessor, the small computer in the EOS 100/Elan, then compares this data stored in its memory from the exposure meter and registers the type of lens used from contacts in the lens bayonet. The computer uses the difference between these two sets of data to calculate the direction and amount of adjustment needed, and then uses this to control the motor in the lens.

The EOS 100/Elan has a cross-type BASIS sensor which, as well as recognizing vertical lines (standard on autofocus systems), is able also to register horizontal lines. However, horizontal lines can only be registered with lenses that have a maximum aperture of at least f/2.8.

An extreme wide-angle lens, an attractive colour atmosphere, and even an everyday subject (a fishing rod) can be turned into something interesting.

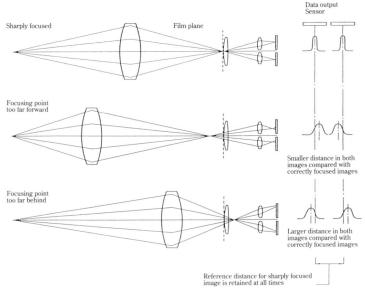

The principle of automatic focusing: focus is achieved by comparing the subject image distance with a reference image distance.

The working range of the autofocus runs from EV 0 to 18 at ISO 100/21°. This means that automatic focusing won't work if the light is either too bright or too dark for the shot. But in order to explain the term exposure value we need to go back a little.

The correct exposure for a subject is controlled by the lens aperture and the shutter speed, depending on the film speed. By changing these two parameters in turn it is possible to let a constant amount of light reach the film, even with different combinations of aperture and shutter speed. If, for example, the amount of light is halved by stopping down the aperture and the shutter speed is doubled at the same time, the same overall exposure will result. So at a given brightness and film speed there are a whole series of aperture/shutter speed combinations which will produce the same amount of light on the film. This is the exposure value.

In order to give a clearer idea of the limitations of the autofocus, it is given as a value for a film speed of ISO 100/21°. Exposure value 1 includes 2 seconds at f/8 as one possible exposure combination.

EV 18 requires 1/4000sec at the same aperture. You can see that the working range of the autofocus is fairly generous, and it has to be very bright or very dark for it to be stretched to its limits. Apart from the brightness, a certain amount of contrast is, of course, also required for the autofocus to be able to function. If this is not available, the autofocus will go on strike straight away.

With the EOS 100/Elan the automatic program of the camera determines suitable combinations itself, so we don't need to worry much about exposure values. In practice it is sufficient if you keep at the back of your mind that the autofocus can simply no longer function if there is either too much or too little light. But apart from this, you'll soon notice when it gets to that stage.

At close range the AF auxiliary light emitter, which switches on automatically when needed, can help if there is insufficient light. It casts an infra-red pattern onto the subject to give the camera's autofocus system the contrast required to focus correctly.

Autofocus in practice

In the centre of the viewfinder image you will see the autofocus frame, the crux of every attempt at focusing. Partial images are projected from this small area to the BASIS sensor, which provides the data needed by the microprocessor in the EOS 100/Elan to make a focus comparison. This small area needs to be aimed at a detail on which the camera can focus. This metering point needs to meet the following requirements:
- it mustn't be too bright (an almost hypothetical demand in view of the wide working range up to exposure value 18, but still conceivable)
- it mustn't be too dark
- it must have sufficient contrast and texture (the autofocus can't focus on a smooth wall)
- no intrusive element (wire mesh or branch) must be within the metering area
- the cross-type BASIS sensor can only focus on horizontal lines with lenses with a maximum aperture of f/2.8 or brighter.

There is a remedy for all these problems. First the most unlikely complication - too much light. This is very unlikely to occur because exposure value 18 is only reached if the exposure demands 1/

Automatic focusing only works without further consideration if the main subject is located in the image centre and is registered by the autofocus frame. The danger is that picture composition is left by the wayside.

500sec at f/22, or a comparable combination. Such values occur if you point directly at the sky. On the ground it's rarely that bright. If it is too bright you've got two options: either switch to manual mode, or fit a neutral density filter over the lens - they are available in different strengths. ND filters cut down the light without affecting the colours.

In darkness and across greater distances manual operation is the easiest and fastest remedy. Should this become necessary, it will be so dark that you either need a tripod or flash. The flash unit is the second option, allowing autofocus operation at shooting distances up to six metres. It emits a red flash, which projects a pattern onto the subject that the autofocus can focus on even in complete darkness.

First lock the focus, then frame the shot and release the shutter. This means a little more effort, but it allows you to pay attention to picture composition. In this case the statue was deliberately given a little more space in the direction it is looking in.

This red flash illumination can also help with smooth surfaces or low-contrast subjects. But as flash illumination is not always desirable, manual focusing is once again the easier alternative. Very often it will simply be enough to move the camera slightly and to aim at a different detail - look for edges in particular. Lightly press the shutter button, focus, and then recompose. The same applies if there are intrusive objects directly in front of the autofocus frame.

One-Shot and AI Servo

Setting: Press **AF** button in order to select the desired focusing mode.

The EOS 100/Elan has an autofocus control system which offers two variants: One-Shot or AI Servo. The One-Shot function uses focus priority so the shutter can only be released when the subject is completely in focus. In single exposure mode the camera will then lock until the focusing system is re-activated by once again pressing the shutter button. In continuous exposure mode - and this is important - you can take as many shots as you want without the focus being re-calculated. Once selected, the distance stays the same. You should select this function whenever you want to have particularly precise focus as the focus is locked by lightly pressing the shutter button, and you can then select the composition at leisure before releasing the shutter.

In the AI Servo setting, on the other hand, the camera registers and calculates the focus continuously. It doesn't matter whether the camera, or the subject, is moving, or both. Even the time taken by the mirror to flip up and the shutter pre-release time is taken into account, and the focus is set predictively, as it were, for the actual moment of exposure. If the motor is set to continuous exposure mode, focus is continually adjusted. In single exposure mode, on the other hand, the shutter button has to be pressed each time.

Tips on automatic focusing

Divide your preparation for the shot into different stages. Automatic focusing and selecting the composition should be separated,

otherwise you run the risk of only producing shots with the main subject dead centre, and that's boring. This is how you should go about it:

- Aim at the main subject, lightly press the shutter button. Focusing is carried out, and this value is stored.

- The exposure value is determined at the same time, which presents an extra advantage because the exposure is assessed where the shot is going to be sharp, and this is usually the most important area in the photograph.

- Now select the actual composition, keep holding down the shutter button half-way, then release.

When put into words, this procedure sounds a lot more complicated and lengthy than it is really is. You'll only waste a fraction of a second by not pressing the shutter button all the way down at the beginning and separating the processes of focusing and releasing the shutter. In the time between the two you can quickly shift the camera to get the right composition.

Tip 1: Don't despair if the autofocus goes on strike occasionally. Just aim at a slightly different place, or tilt the camera slightly.

Tip 2: If nothing else helps, switch off the autofocus. This will always help.

Tip 3: With some EOS lenses the front element and filter thread will turn during distance setting. However, polarizing filters, star effect filters and a few others need to be kept in a certain position to work. Here it is best to focus manually and then precisely align the filter. The autofocus now can't adjust the focus when the shutter is released and destroy the filter's effect.

Tip 4: Finally, if nothing else helps, every EF lens can be switched from automatic to manual focusing by means of a slide switch. If you use this function frequently, please be aware that some EF lenses can be fine-focused manually in automatic mode.

Photographic practice 2 -
making the most of your camera

In the first practical chapter you learned how to handle the EOS 100/Elan, and this mainly meant making the right adjustments and selecting a suitable program. Now we're going to start on the finer details of photography. In this chapter you will find out how to use the extended features of the EOS 100/Elan - and there are quite a few of those.

Please note that all the settings we are going to make here will be deactivated as soon as you change over to the other side of the command dial. Selecting the green program or one of the image zone shooting modes will not only block all the custom functions you have selected, it will also cancel settings such as metering mode, film winding mode or autofocus function, and reset the camera to the standard settings.

Automatic program 'P'

Setting: Set the command dial to **P**.

The first automatic programs were comparatively simple, and many experienced photographers considered them hybrids that couldn't really do much. So they were clamouring for an OFF button and, quite rightly, for the well-proven aperture and shutter priority modes. The second generation of automatic programs offered several programs with different priorities, and there was an additional telephoto and a wide-angle program. The telephoto program, for example, preferred faster shutter speeds to prevent blurring. The wide-angle program, on the other hand, selected smaller apertures in order to gain more depth of field. Both were quite useful.

All you need to do with the EOS 100/Elan is set the command dial to **P**, and the camera will do the rest. The special feature of this program is that the EOS 100/Elan varies the program's characteristics depending on the focal length and speed of the current lens.

Photographs created according to the desires and ideas of the photographer - this, too, is possible with the EOS 100/Elan. In this chapter you will find out how to determine precisely the depth of field, exposure and more.

This ensures that the automatic program of the EOS 100/Elan always selects a sensible combination of shutter speed and lens aperture, eliminates camera shake as far as possible, without neglecting the depth of field whenever it is bright enough.

The big difference compared to the automatic programs described in the first practical chapter is the fact that, by selecting the P program, the photographer keeps open the option to make adjustments. Any programmed custom functions (CF) will remain active, and so exposure lock, program shift, exposure compensation and metering mode can be selected.

You will soon see what you can do with all this, by finding the relevant headings. These functions can also be used in shutter and aperture priority.

At a glance:
- The automatic P program varies according to the focal length.
- Full aperture is used until a shutter speed sufficient to avoid camera shake (1/focal length) has been reached. This ensures that the risk of camera shake is eradicated as quickly as possible.

- After this point aperture and shutter speed are adjusted in proportion. The program aims to achieve as favourable a compromise between aperture and shutter speed as is possible.
- The flash only switches on if it is activated by means of the small button at the top left-hand side of the camera.
- In P mode the photographer retains the option of intervening (see: *Program shift, Exposure compensation, Automatic exposure bracketing, Metering mode, Exposure lock*).

Shutter and aperture priority

Setting aperture priority: Set command dial to **Av**.
Setting shutter priority: Set command dial to **Tv**.

Compared to the automatic program, aperture and shutter priority have one advantage - the photographer decides on one important parameter and leaves the other one to the EOS 100/Elan.

In aperture priority Av, the main dial is used to select an aperture and then the camera determines the shutter speed to go with it. This gives you the opportunity of precisely controlling the depth of field, or select an aperture which gives the best lens performance. As a rule of thumb, two stops down from the maximum aperture usually produces the best performance from a lens.

In shutter priority Tv, on the other hand, a shutter speed is preselected with the main dial, and the EOS 100/Elan automatically selects the aperture. This way you can ensure that the shutter speed never falls below a point likely to give camera shake, or cause blur with fast-moving subjects.

Don't underestimate the 'simple' automatic programs - they allow you to set far clearer and more precise priorities than the automatic program. Aperture priority is the right choice, for example, when depth of field is the prime concern, and not much else matters. Whereas the aperture can change constantly in all other automatic exposure programs, this option gives you a guarantee that, once selected, the aperture really remains fixed.

On the other hand it is, of course, possible to influence the shutter speed to some extent by selecting the aperture. A wide aperture always produces faster shutter speeds than a small one. When photographing in aperture priority, a quick glance in the viewfinder

In aperture priority mode you preselect the aperture - the camera automatically determines the shutter speed, and you're in control of the depth of field.

If you need certain shutter speeds - to prevent speed blur, for example - shutter priority is the right operating mode. You preselect the shutter speed, the camera determines the aperture that goes with it.

is usually enough to preselect the aperture to suit the current situation (brightness, desired depth of field, shutter speed and so on). With a telephoto lens, for example, a suitable aperture selection can also help to ensure that the shutter speeds don't become too slow.

The same applies to shutter priority, only the other way around. Whilst the shutter speed is the most important concern, selecting a suitable speed also allows the aperture to be controlled to a certain extent in order to determine the depth of field.

Aperture and shutter priority are very useful in connection with partial metering. Only one of the two parameters is changed during exposure measurement, but both aperture and shutter speed are adjusted in the automatic program. Contrast measurement, by metering from the brightest and darkest part of a subject, can therefore be captured in either speed or aperture stops at a glance. The difference between the brightest and darkest measurement can be read off directly. So you can aim at the bright and dark sections that are important for the shot, and as long as the difference does not exceed five aperture stops you can be sure that all important details will be reproduced in the shot.

At a glance:
- Aperture and shutter priority allow clear preselections to be made, which means that your photographic objective can be realized more precisely than with the program mode.
- In aperture priority the photographer selects the aperture, and hence the depth of field.
- In shutter priority the shutter speed is determined by the photographer. He is in control of the sharpness of movement.
- When values are selected which exceed the exposure range - such as too slow or too fast a shutter speed - the automatically selected value will flash to point to out incorrect exposure.

Automatic depth of field program

Setting: Set command dial to **DEP**.

Depth is a program variant which proves that technological progress really can bring advantages. On the EOS 100/Elan this was achieved in an almost revolutionary way. All you have to do in the **depth**

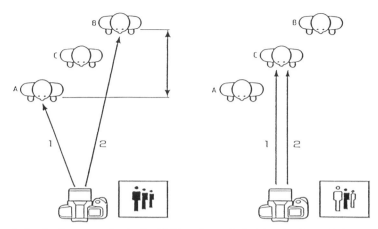

In the **depth** program the depth of field can be precisely determined by metering a closest and farthest focus point (left). By metering two points that are very close together you can also deliberately limit the depth of field very tightly.

The depth of field program allows you to determine the focus precisely.

79

program is to select the nearest and farthest point you want in focus. The indication **dEP 1** or **dEP 2** in the viewfinder signals that the nearest and farthest point have been registered. The automatic program will do everything else. It will determine the depth of field zone, the aperture and the optimum focus distance, and will select a suitable shutter speed to go with these values. Don't worry if the EOS 100/Elan sets the lens to an apparently unsharp position after you have selected the area of sharpness, making the centre of the viewfinder appear unsharp. This will be the optimum focus plane that allows everything to fall in focus, from the front right to the back, with the lens stopped down as little as possible.

Increasing the depth of field means decreasing the aperture size, which in turn necessitates a slower shutter speed to compensate. So watch out for the green camera symbol in the viewfinder which signals the risk of camera shake.

This program is, of course, not able to transcend the laws of physics, but needs to take them into account. It cannot make the impossible possible. A depth of field zone extending from the tip of the nose into infinity simply can't be done, even with the EOS 100/ Elan. So you need to select the depth of field zone within sensible limits, and not expect the impossible. And don't use an extreme telephoto lens if you want the greatest possible depth of field.

When working with this automatic variant you should also remember that you can use it not only to extend the depth of field, but also to narrow it down so much that you can separate a subject from the background. But this, too, is only possible within the confines of the law of physics. At its maximum aperture, a 24mm wide-angle lens, for example, has a fairly large depth of field zone that's impossible to reduce.

At a glance:
- In the automatic depth of field program you first need to select the closest focusing point **dEP 1**. To do this, lightly press the shutter button.
- Let go of the shutter button, select and fix the farthest focusing point **dEP 2**.
- Let go of the shutter button, select the composition and once again press the shutter button. The program will now calculate how far the lens needs to be stopped down and what the exposure needs to be. You can now release the shutter.

- Try to limit the depth of field as precisely as possible - this is what this program variant is designed for. Selecting too great a depth of field to be on the safe side will only have negative effects because, as the aperture needs to be stopped down further, the shutter speed becomes slower.

- In the depth of field program you need to watch out for a camera shake warning. Rest the EOS 100/Elan on something or use a tripod if a warning appears.

- Don't forget: this program allows you to select a particularly great, or particularly shallow depth of field.

- Wide-angle lenses help to create a great depth of field zone.

- Telephoto lenses help to create a shallow depth of field zone.

Program shift

Setting: Having selected aperture priority, shutter priority or the automatic program, turn the main dial.

Program shift via the main dial is possible at any time in the automatic program, shutter or aperture priority, allowing the photographer to change the nature of the shot with a simple turn of the dial.

The important thing to realize here is that the exposure doesn't change at all! With program shift the amount of light reaching the film will always remain constant, but what does change is the aperture/shutter speed combination. If you try the program shift, watching the values in the viewfinder, you will notice that both indicators always change at the same time: if the aperture is stopped down (say from f/5.6 to f/8), the shutter speed will be changed by the same increment (from 1/250sec to 1/125sec, for example).

The film doesn't care whether it is exposed at f/2.8 and 1/500sec or f/16 and 1/15sec. The same amount of light will reach the film in each case, as the aperture was stopped down by five stops and the shutter speed slowed down by five steps. The photographer, however, can't ignore this change, as the depth of field increases at the expense of slower shutter speeds. Slow speeds increase the danger of camera shake, and may necessitate the use of a tripod. A wide aperture, on the other hand, allows fast speeds, but the depth of field is reduced.

At a glance:
- Program shift does not change the exposure value.
- Aperture and shutter speed change interdependently, and can be controlled to within half a stop.
- Program shift is the ideal means to set new priorities quickly, say to select a faster shutter speed because you're shooting a sports subject, or choose a narrower aperture in order to get as much depth of field as possible.

Exposure metering

So far you have not yet set anything on the camera that will change the metered exposure. Before we start on these options, you need to find out a little about the basics, in order to be able to use corrections properly.

First, you should know that the exposure meter is calibrated to a medium grey that corresponds to a reflectance of 18%. This value

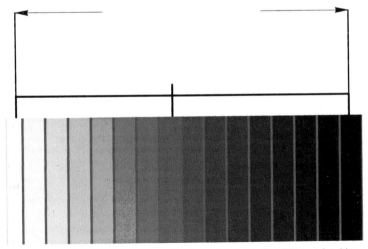

The grey scale wedge shows areas ranging from white to black at different densities. The difference in density from one area to the next approximately corresponds to one-third of an aperture stop. The value the exposure meter is calibrated to lie roughly at the centre of this scale.

82

comes from the assumption that normal subject contrast is 1:32. If you take the mean value from this, you will get the medium grey with a density of 0.75, or a reflectance of 18% (17.68% to be precise). Exposure measurement therefore reproduces the metered area as medium densities, thus falling at the centre of the exposure range of a film.

The metered subject detail will always be reproduced at medium densities, even if it is very bright or very dark. White kitchen units are reproduced as just the same grey as a black cupboard. In one case the exposure will be insufficient, in the other, too generous. Correct exposure results only if the metered subject corresponds to the calibrated mid-grey value.

With partial metering in particular, a lot depends on choosing the right area to measure from - it should correspond as closely as possible to this medium grey. With the larger measurement area of centre-weighted average metering, things are less critical. Here the whole of the matte focusing screen is taken into account, although emphasis on the image centre, and so the whole subject can be treated as a medium grey. In this case the result will be fine if the distribution of light and dark is even, and adds up to a medium overall grey, and if contrast isn't too great. The choice of metering area is even less critical with evaluative metering where the subject is metered and analysed in different partial zones.

However, partial metering is best for selective exposure. With centre-weighted average metering, and even more so with evaluative metering, the photographer won't know exactly what weighting the automatic program will apply where. When partial metering has been selected, however, the metering point can be clearly recognized by the circular marking on the matte screen.

Exposure lock

Setting: Press the * button on the top right-hand side.

Exposure lock is a fast and reliable method for precisely determining the exposure. The exposure value is metered at the press of a button, remaining locked until the shutter button is pressed. This makes little sense when evaluative metering has been selected, as

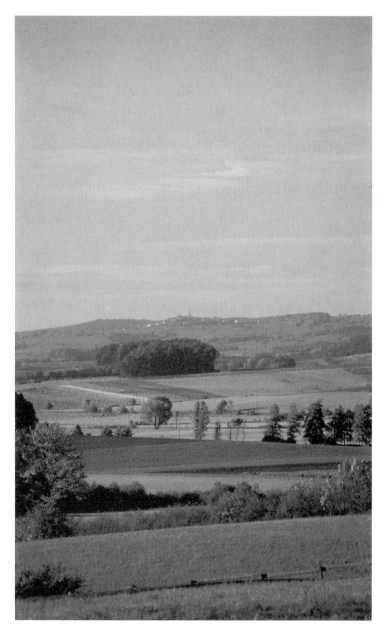

the photographer cannot judge how and to what extent the zones have already been weighted.

It can be more useful with centre-weighted average metering, with high-contrast subjects like a landscape with a plenty of sky. If the landscape is to be exposed properly, you need to tilt the camera downwards a little, lock the exposure, and then compose.

Exposure lock is particularly useful when used in conjunction with partial metering, as the metering area (medium grey!) can be selected with precision and then locked.

With subjects that have a lot of contrast, or are otherwise problematic (very bright or dark), you can aim at a substitute point and lock that in. When making a substitute measurement with the exposure lock function, just select a suitable point that roughly corresponds to a medium grey. Fortunately suitable spots for substitute measurements are easy to find, particularly when you're outside on location, where things usually have to be quick. Look out for a green field or the grey surface of a road.

There is one situation, however, when the exposure lock function will always be useful: if you select the custom function **CF 5**, pressing the lock button will not only lock the exposure, but also stop down the EOS 100/Elan to let you visually check the depth of field.

At a glance:
- The exposure lock function can lock any aperture/shutter speed combination indicated in the viewfinder.
- This value is maintained even if the camera is moved to a different composition.
- The exposure lock function is needed only in extreme light situations or with predominantly bright and dark subjects.
- The exposure lock function is cancelled when the shutter is released. If you don't like the value set, quickly turn the command dial to another operating mode and back again. This also cancels the value.
- When the custom function **CF 5** is selected, the camera stops down when the exposure value is locked - useful for checking the depth of field.

Thanks to the exposure lock function, extreme light conditions are no problem. Simply aim at a suitable metering point - in this case the foreground - and lock the exposure.

Exposure compensation

Setting: Turn the quick control dial on the back of the camera.

Exposure compensation allows the exposure to be adjusted in a range of between +2 and -2 exposure values, in 1/2 exposure value increments. The compensation factor appears on the scale of the EOS 100/Elan. A negative compensation means that the film will be exposed to less light - it will be underexposed. Conversely, it will be overexposed if a positive setting is selected. The scales on the LCD display and in the viewfinder show the exact compensation set.

This option can be utilized in order to 'push' a film deliberately, or to achieve special high or low key effects. With multiple exposures, too, an exposure compensation dependent on the number of multiple exposures is required.

It doesn't make much sense to use compensation for a single shot - the method is a little complicated and there's also the danger that you might forget to cancel it. The exposure lock function is far more suitable if you want to deliberately over- or underexpose a single shot, or even a few shots. But if you want to take a whole series of shots with non-standard exposure, then by all means use some exposure compensation.

Automatic exposure bracketing

Setting: Select **AEB** and input the bracketing increment using the main dial.

If you want to save yourself some of the decisions involved in using exposure compensation, you can use the automatic exposure bracketing function, which takes three exposures of a single subject,

Illustration (right):
The partial metering mode of the EOS 100/Elan can even cope with extreme light conditions such as this.

Illustrations (following pages):
Thanks to zoom lenses, you don't need too much equipment when travelling to distant countries, and yet you can still cover perfectly all shooting situations - the results speak for themselves.

differing by increments of between 0.5 and 2 aperture stops. With a preselected bracketing increment of 1 stop, for example, one shot will be underexposed by one stop, the second correctly exposed, and the third overexposed by one stop.

This function is particularly useful for slide film which, as you know, has a very narrow exposure latitude. Even a difference of half a stop can make the difference between perfectly exposed and only acceptable results. With negative film, bracketing increments can be greater - one to one-and-a-half stops are possible without any problems.

Centre-weighted average metering

Setting: Press the button to the left underneath the command dial and turn the main dial until the rectangular symbol appears.

The characteristics and advantages of evaluative metering have already been covered in the first chapter on photographic practice, as most image zone shooting modes use it. Its great disadvantage has also been mentioned - photographers have no means of judging what weighting each zone has been given.

Centre-weighted average and partial metering allow you to work more precisely, and are particularly interesting for slide photographers. After all, they need to achieve spot-on exposures because of the film's narrow exposure latitude, and the limited ways of making corrections later. With colour negative film, on the other hand, it doesn't matter which metering mode you decide on - the wide exposure latitude will put things right.

You can see the effects of the different metering modes if you mount the EOS 100/Elan on a tripod and then switch between the different methods. Depending on the contrast of the subject, the values indicated in each case will differ to a greater or lesser extent.

An experiment with the zoom lens: a slower shutter speed was selected (1/8sec), and the focal length was adjusted during shutter release.

In centre-weighted average metering mode the entire image area is metered, with stronger weighting of the image centre.

Centre-weighted average metering measures the overall brightness of the subject and averages it out. To be sure of capturing the main subject the image centre is taken into account to a greater degree than the edges, resulting in a 'centre-weighted average measurement'.

With average subjects without pronounced predominance of brightness or darkness this method works very reliably. The centre-weighted characteristic of this method is both its advantage and its disadvantage. With balanced subjects it allows fast and safe exposure metering, but you can never be quite sure how the tones will fall in the photograph. Centre-weighted average metering is particularly useful in situations where there isn't time to give a great deal of thought to exposure and selecting a metering point.

At a glance:
- Centre-weighted average metering is a reliable metering method in non-critical light conditions.
- Problems occur with high contrast and predominantly bright or dark subjects.

Partial metering

Setting: Press the button to the left below the command dial and turn the main dial until the rectangular symbol with a circle (but without a dot in the centre!) appears. The metering area is indicated by a circle in the centre of the matte screen.

Partial metering allows you to meter an important part of the subject. At 6.5% of the entire image area, the segment metered is

substantially larger than with spot metering, which typically covers 1%. The measurement is therefore not quite as specific, but on the other hand, the choice of metering area is not as critical as it is with spot measurement. However, the metering area still needs to be selected with care. Partial metering is suitable whenever you need to place emphasis on a specific subject detail. Please note that the

In partial metering mode the metering result is particularly strongly weighted towards the image centre.

measurement will only be correct if the density of the metered subject detail corresponds to a medium grey. So you should select the metering point with care, and make good use of the exposure lock.

At a glance:

- Partial metering is strongly centre-weighted, the metering area is precisely defined.

- Thanks to the precisely defined metering area, with the help of the exposure lock function the exposure can be accurately determined and locked in advance of shooting.

Manual exposure

Setting: Set the command dial to **M**.

This setting allows a completely manual exposure control. The aperture is selected with the quick control dial on the back of the camera body, the shutter speed with the main dial. The selected aperture and shutter speed are displayed in the viewfinder and on the data panel; over- and underexposure, or correct exposure is signalled by two triangular symbols with plus and minus markings. If both are lit simultaneously, the exposure is correct.

Because it is slow to set, this manual method is only suitable for studio photography and painstaking creative photography. It will only be used in exceptional circumstances, for example if you are shooting with studio flash, fixed shutter speed (sync speed) and fixed aperture.

Multiple exposure

Setting: Set the command dial to multiple exposure (two overlapping rectangles). Select the desired number of exposures, up the maximum of 9, with the main dial, and then turn the command dial to the desired program.

The film winding function is switched off for multiple exposures, and the preset number of exposures are made on one and the same frame. Depending on the subject brightness, an exposure compensation factor has to be selected to prevent the shot from being overexposed. Try a compensation factor of -1 for two exposures, -2 for four exposures. Although greater compensation factors aren't possible with the exposure compensation function, you can get round this by using the manual exposure mode. As the required compensation depends on the subject, it is advisable to shoot some tests before taking important shots.

Bright moving subjects in front of a deep black background come across best. Multiple exposure works like a slide fade, as a second subject can be exposed onto dark sections and the brighter this section to start with, the more the effect is reduced.

The EOS 100/Elan cancels the multiple exposure function as soon as the preset number of exposures has been made.

Long exposures

Setting: Select the manual exposure mode and turn the main dial until **buLb** appears on the data panel.

Apart from the shutter speed range between 1/4000sec and 30 seconds, you can also select the B setting - **buLb** will appear on the data panel. The shutter will now stay open for as long as the shutter

Because there is usually a lot of contrast and because of the reciprocity characteristics, long exposures are not so easy, particularly on slide material. But they are worth the effort, as they often produce quite surprising light and colour effects. A tip on exposure metering: meter on the highlights (partial metering) and add 2 to 2.5EV (exposure compensation).

button remains pressed. If the shutter button on the camera itself is pressed, this could easily lead to camera shake. This is particularly true if the tripod and tripod head are not completely stable, as any movement you cause would be transferred to camera body and tripod.

Unfortunately the EOS 100/Elan does not have a cable release connection, which means that the shutter button on the camera body has to be pressed for the entire time. But you could use the optional remote control.

Please note that the EOS 100/Elan is sensitive to light entering through the viewfinder eyepiece during long exposures - this could lead to incorrect exposure. To avoid this you should remember the small eyepiece cover, located in the carrying strap.

At a glance:

- The eyepiece should be covered during long exposures.
- The reciprocity characteristic of the film, given in manufacturer's data, needs to be taken into account.

Programming custom functions

Setting: Select **CF** with the command dial, set the program number (CF 1 to CF 7) with the main dial and switch the function on or off with the * button.

You can define a number of interesting specific functions yourself, to adapt the EOS 100/Elan to your special requirements. CF is short for 'Custom Function'. If you select a function number, a number will appear to indicate whether or not the function is activated. It is switched off if a **0** appears, activated if a **1** is displayed. The data panel will signal **CF**.

Please note that these custom functions do not become effective if you select the green program or one of the image zone shooting modes!

CF 1: A **1** switches off the automatic film rewind at the end of the film. This is a very useful function in certain situations (like in church, concert and so on), as film rewind is by far the loudest noise the EOS 100/Elan makes.

CF2: If you select **1** here, a system flash unit (built-in or external) will be synchronized for the second shutter curtain. Flash units with a simple central contact will continue to fire as normal with the first shutter curtain.

CF 3: This switches off the automatic film speed setting with DX-coded films. Be careful with this function! Once selected, the preset film speed will be maintained permanently. You should only use this function if you want to expose a whole supply of identical DX-coded films at a different speed. A good example is if you want to 'push' a film type during a concert. Don't forget to switch off this function immediately afterwards.

CF 4: This enables you to switch on or off the red AF auxiliary light. In the standard setting (**0**) the light is switched on. Program **1** in order to switch it off.

CF 5: A very interesting function can be selected with CF 5. If you set it to **1**, the lens is stopped down when you press the AE lock button. In addition, the exposure is once again metered and locked at every press of the AE lock button *, otherwise only one value can be locked. This is cancelled when the shutter is released or when you switch to a different program. CF 5 should therefore always be set to **1**.

CF 6: This function allows you to decide whether or not you want the warning beep on. If the beep gets on your nerves, you can switch it off with this setting.

CF 7: If a **1** is selected here, then the mirror is pre-released when the self-timer function is used. The mirror will flip up when the shutter button is pressed, and the self-timer runs for 10 seconds before the exposure is made.

Lenses -
increase your picture power!

Zoom v fixed focal length

When buying a lens you need to think about the suitability of zoom lenses compared with lenses of fixed focal lengths. Decide which is preferable to you. It is possible to cover continuously all focal lengths between 28mm and 300mm with two zoom lenses, but around seven separate lenses will be necessary just to cover the most important focal lengths within this range: 28,35,50,85,135,200,300.

But this question is posed in the wrong way - the two possible alternatives are so very different. The lenses available for the EOS 100/Elan clearly demonstrate the priorities of lens construction, both now and in the future. Fixed focal lengths are increasingly designed for special applications and are either particularly fast, or else suit areas like macro photography. Their optical correction is excellent, and distortion is so low it tends towards zero with standard and telephoto lenses. In addition, high-quality fixed focal lengths are two to four times as fast as zoom lenses. In practice this means that fixed focal length lenses can be stopped down by one or two stops, which gets them into their top performance range, while zoom lenses still have to be used at the maximum aperture. Alternatively, shutter speed can be reduced correspondingly, in order to prevent a danger of camera shake. The limits of available light photography are far more generous with fast fixed focal lengths, and they offer more chance to use slow, sharp film with fine grain.

Whilst zoom lenses are universally used for most applications, the fixed focal length lenses in the EOS range are specialists for macro or wide-angle photography or - like the 100mm,f/2.0 used for this shot - for available light photography.

Two tendencies can be noted in Canon's development of the zoom lens. On the one hand, the zooms on offer cover a wide focal length range, on the other Canon uses particularly high-quality elements to increase the optical quality. Sometimes the two are combined, like in the case of the EF 100-300mm,f/5.6 L. Obviously, in comparison with a fixed focal length optic the zoom lens has the advantage of the greater focal length range, but it also works out cheaper when compared to the number of fixed focal lengths it replaces.

The variable focal length lens can save frequent lens changes and reduces the weight of the equipment. With a zoom that covers a range from wide-angle to telephoto, like the EF 28-80mm,f/2.8-4 L USM, the photographer can tackle most shooting situations. Its reduced speed and the slightly more pronounced distortion can be a disadvantage.

At a glance:

There are now really only four good reasons for buying fixed focal lengths instead of a zoom lens:

- Zoom lenses are comparatively slow, which means that fast fixed focal lengths are indispensable in available light photography.
- Zoom lenses have a restricted close-up range and are corrected for greater distances. This means that special lenses are required for ambitious macro photography.
- Fixed focal length lenses can be optimally designed and corrected for a specific application - examples are macro lenses or the EF 24mm,f/3.5 TS-E.
- Finally, there are still gaps in certain areas like extreme wide-angle and telephoto photography. Alternatives to fixed focal lengths below 20mm and above 300mm are not in sight, at least from Canon.

This is how Canon builds excellent lenses

Aspherical elements

With aspherical lens elements, the degree of curvature varies over the surface, compared to normal elements with a single spherical curvature. Aspherical elements give the lens designer much greater freedom to design highly corrected lenses with fewer elements, and so reduce weight. At one time production of aspherical elements was very difficult and expensive, so they were confined to specialist lenses where cost was irrelevant. Canon has developed the technology to a stage where aspherical elements can be incor-

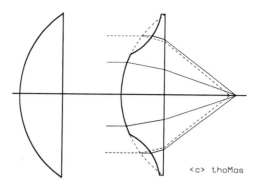

Unlike conventional lenses (left), aspherical lenses (right) have several curvature radii. This means that even marginal light-rays are refracted into the same focal point. In comparison, the dotted line shows the focal point difference that occurs with a conventional lens.

<c> thoMas

porated into mainstream lenses. Thanks to a special moulding method, these lenses can now be produced at affordable prices.

UD and fluorite glasses

UD and fluorite glasses with very low dispersion characteristics, which eliminate chromatic aberration, are predominantly used by Canon for very fast telephoto lenses.

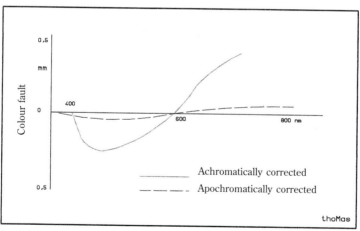

Special UD and fluorite glass lenses achieve a substantial reduction in colour fault (chromatic aberration). The solid line shows that an achromatically corrected lens is well-corrected for wavelengths of 400nm (nanometres) and 600nm, but a so-called secondary spectrum occurs between these. Light of these wavelengths does not arrive exactly in the calculated focal point.
Not so with an apochromatically corrected lens, where the secondary spectrum tends towards zero.

Canon mostly uses these special element shapes and glass types in the L series, which is recognizable by a red ring and the letter L in their name. Chromatic and spherical aberration are fully corrected in these lenses. This means that they fulfil all the requirements made of an apochromatically corrected lens, and they show excellent reproduction quality even at their maximum aperture. Other manufacturers mostly signify this by adding the suffix APO to the lens name.

Floating elements
Floating elements are used on a number of EF lenses. When setting the distance, it is not just the entire optical system which moves for focusing, but the relative distance between individual element groups is also changed. This allows an improvement in the optical quality, particularly in the close-up range.

Internal focusing
This means that the entire optical system does not move, but only a rear element group. This technique is used especially on EF telephoto lenses with long focal lengths, helping them to autofocus faster and more precisely, without much change in their centre of gravity.

Focal length
Focal length and speed are the two basic parameters which define a lens. Every lens is characterized by its technical data, given by Canon in the following form: EF 135mm,f/2.8 Softfocus. 'EF' means that it is an autofocus lens, 135mm is the focal length - in this case a medium telephoto - and f/2.8 is the maximum aperture or speed. Any suffixes give details of special characteristics, in this example the ability to change the correction of the lens in order to achieve softfocus effects.

The ability to change focal lengths quickly and easily is probably the main reason for the success of the SLR camera, because it opens up a wide range of creative possibilities. A telephoto lens can bring distant subjects close - much like binoculars. A wide-angle lens allows photography in the tightest spaces, letting you squeeze a lot into a frame. But the possibilities of different focal lengths are far from exhausted by such uses. To use a wide-angle lens exclusively in tight interiors and a telephoto only for shooting the

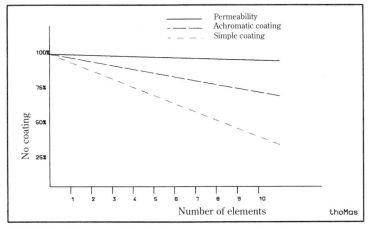

Achromatic coating can substantially improve the brilliance of a lens. The design of good zoom lenses was only made possible by achromatic coating - the losses of uncoated or simply coated lenses would be too great with so many elements.

obligatory church clock would be wasting the creative scope of photography.

A wide-angle lens has a greater depth of field than a telephoto lens at the same aperture setting. This phenomenon should be considered in connection with the **depth** program option, as a wide-angle lens has to be stopped down less than the telephoto lens to achieve the same depth of field. This allows - still assuming the same shooting conditions - a faster shutter speed and therefore greater sharpness of movement. Moreover, wide-angle lenses have a shorter focal length to start with, which allows faster shutter speeds with less danger of camera shake.

The different effects of various lenses can easily be categorized by means of their focal lengths. When shot from the same distance, the subject is reproduced at twice the size when the focal length is doubled, but of course this means that only a quarter of the original subject area is captured. When changing from a 50mm standard lens to a 200mm telephoto, one-eighth of the original image area is therefore reproduced on film at four times the size.

So the depth of field can be influenced by the choice of focal length. You can think of a wide-angle lens as showing the subject in its wider context. Subject and surroundings are reproduced razor-sharp, giving an impression of space. A telephoto lens, on the other hand, singles out a subject, placing it in front of a fairly unsharp background. As the focal length increases, the subject will appear increasingly flatter, and so the impression of depth is lost to a certain extent. To see what I mean, go out and take a shot of a flower with a wide-angle lens, then with a telephoto, and compare the two.

The difference in depth of field is a phenomenon which applies to different focal lengths at an identical reproduction ratio and identical aperture. So it is quite possible for a wide-angle shot taken on an overcast day to have a shallower depth of field than a telephoto shot taken on a bright day. If you want to achieve the shallowest depth of field possible with a telephoto lens on a bright day, it could therefore even be advisable to reduce the depth of field further by using the **depth** program. With a wide-angle lens it is always advisable to use the depth of field program for important shots, and

Wide-angle focal lengths usually show the subject in its surroundings and are distinguished by comparatively great depth of field.

take the photograph from a tripod if necessary. This is because a wide-angle shot is usually expected to have razor-sharp focus, from the foreground right to the background. But don't let this prevent you from experimenting with wide-angle and shallow depth of field.

At a glance:

Choosing a focal length means making a preliminary decision regarding the depth of field. Focal length and depth of field are interdependent in the following way:

- The depth of field depends on the focal length: short focal lengths produce great depth of field, long focal lengths shallow depth of field.

- At a constant focal length the depth of field is influenced by the following parameters:

(a) narrow apertures produce great depth of field.

(b) greater shooting distances produce greater depth of field.

- Doubling the focal length at a constant shooting distance means a doubling in reproduction size.

Telephoto focal lengths generally concentrate the eye on the essential elements of the shot and separate the subject from the background.

If a subject is shot with different focal lengths from the same shooting position, the framing changes, but the perspective stays the same. As the focal length increases, the subject is magnified. A sectional enlargement from a wide-angle shot results in exactly the same picture as a telephoto shot. A different perspective is only achieved by changing the shooting position.

106

Perspective

The focal length you use also influences the perspective, in other words the way things look. The widely used terms 'wide-angle perspective' and 'telephoto perspective' have led to many misunderstandings. The perspective does not change if the shooting position remains the same, but in fact a telephoto lens simply captures a smaller section of the same image. This does, of course, change the impression of the shot, which is why this is often described as wide-angle or telephoto perspective. But that isn't quite right.

In fact it would be a bad idea to stay rooted to the same spot, simply changing the focal length. When using telephoto lenses this is particularly tempting, as it's so easy just to change the focal length. This temptation is sometimes even described as a disadvantage of this type of lens. In fact, the ability to select the zoom ratio as quickly and easily as the shooting position should really be welcomed. But you shouldn't just leave it there - give some thought to your subject.

Every focal length probably requires a different view, particularly when dealing with the same subject. Get close to your subject and determine the best shooting position for every focal length separately. If you do this, the term perspective can rightly be used because the perspective changes every time you change your shooting position. A wide-angle perspective is distinguished by over-emphasizing of the relative size of things. What is close appears particularly large, more distant things very small.

To see this effect, try a portrait shot, using the shortest focal length you have. The nose is very close, the eyes further away, and as the natural proportions are distorted the portrait will look unnatural, even downright ugly. But you should still take this shot, for educational purposes, because what you can see through the viewfinder will always look a little different on the two-dimensional photograph. Keep it as an example. Now, using the same lens, go to your telephone and aim the camera at it from the side. You will notice the same change in its proportions, but this time the effect will seem quite interesting. Take this shot, too, and keep it. You will see that something which has quite a detrimental effect in one case, can be just what you're looking for in another context.

The subject will have completely the opposite effect when viewed through a telephoto lens. The proportions become flatter - more or less so, depending on the focal length. Take a moderate telephoto lens - around 85mm - or set your zoom lens to this focal length. 70mm is OK, too. Now take the portrait shot. As the proportions will not be reproduced to the same extent, the face will appear far more natural. Moreover, the shooting distance will increase while the reproduction ratio stays the same. For photographing people this is quite a handy side-effect as you don't have to get so close to your subject. Repeat the same shot with the telephone as your subject, compare it to the first result with the wide-angle lens, and you will get a more boring shot.

What you have just demonstrated are the effects of different focal lengths which may be quite marked. But you shouldn't deduce from this that a wide-angle lens is generally unsuitable for photographing people. Glamour photographers, for example, like to use moderate wide-angle lenses, as these can make the subject's legs look nice and long. Conversely, a telephoto lens can be well-suited for documentary photography, when converging lines are to be avoided as much as possible. As you can see, there are no universal rules. You therefore need to experiment with different focal lengths.

In summary, we can say that a short focal length will dramatize the way things look, whilst a long focal length will produce more balanced shots. But you should only take this as a guide, just as you should use all my advice critically. It's you that takes the photographs, so you should let your very personal view of things influence your shots. Your own views may be quite different from prevailing expert opinion, and remember that the subject itself can create very different effects. A landscape with clouds looming before a thunderstorm will look very dramatic when shot with a wide-angle lens. But however impressive the clouds may be, they'll probably just be boring with a telephoto lens. But it can be completely the opposite.

An overview of a poster hoarding appears trite, but a frayed patch of colour picked out with a telephoto lens can be very effective. This means that our recently established focal length guide has already collapsed. But one rule does remains - approach every new subject afresh.

Short and long focal lengths are useful for illustrating their different effects. I have somewhat neglected the standard lens with

50mm focal length. This lens captures an image in a way that roughly corresponds to that seen by our eyes. It would be wrong to equate 'normal' with 'boring', 'moderate' would be better. Whilst the standard lens used to be the first choice with a camera, the popularity of zoom lenses nowadays means that it has almost become a specialist lens. As many as seven of the Canon zoom lenses currently available cover a focal length range that includes 50mm. The 50mm focal length in the shape of a standard lens is therefore becoming increasingly dispensable. Nowadays its strengths lie predominantly in the special application as a particularly fast lens, or as a macro lens with extreme extension.

Opinions are strongly divided as to which focal length is the easiest to master. Often the advice is 'get close to the subject' because it is perhaps easier to take good shots simply by concentrating on the subject. The multitude of detail that can be captured with a wide-angle lens can easily distract the viewer from the main subject. On the other hand, this very same point gives us the opportunity to show something of the subject's surroundings, to put it into context. My advice to you is to experiment with all the focal lengths available to you. To establish rules, to assume that landscapes are always shot with wide-angle lenses or people always with the 85mm telephoto, would be making things too easy for you. It would also mean throwing away many creative possibilities and ways of expressing yourself photographically.

Speed and aperture

The speed of a lens is the maximum aperture of the iris diaphragm. The odd figures ($f/1.4$, $f/2$, $f/2.8$, $f/4$ etc.) come from the fact that the aperture is a ratio between the focal length and the effective lens diameter. This ensures that the same aperture number represents the same amount of light reaching the film, regardless of the lens used.

An f/number of 2.0 therefore means that a lens with 50mm focal length has an effective aperture of 25mm ($50/25 = 2.0$). With a 200mm focal length lens the effective aperture would need to be as much as 100mm ($200/100 = 2.0$) in order to achieve the same speed of $f/2.0$. This explains why fast telephoto lenses have such huge front elements, and why they are expensive.

The most important data is engraved on the front ring of every lens: focal length and speed.

With every lens, whatever its focal length, the same f/number therefore describes exactly the same amount of light reaching the film. Conversely, if two lenses have different speeds, the one with the smaller f/number is the faster one. It's a bit complicated: a smaller number describes a larger opening, and vice versa. But it has become common usage to talk of a small aperture when the opening is small. A large aperture consequently has the larger diameter. But you can avoid all of this by getting used to thinking and talking in f/numbers.

The following aperture range covers the maximum apertures of all available EOS lenses:

f/1.0 - f/1.4 - f/2 - f/2.8 - f/4 - f/5.6

Some lenses have a speed that lies between two of the above f/numbers, such as f/1.8 or f/4.5. For the sake of clarity I have only given the international aperture range in full increments. In this range, each step from left to right means a halving in speed. A lens with a speed of f/2.8 needs twice the amount of light for the same shot as a lens with a maximum aperture of f/2. This means that, to achieve the same aperture/shutter speed combination for the same subject at the same brightness, either the EOS 100/Elan has to set

Festivals and carnival scenes are also a feast for the photographer. On such occasions you can find many colourful and expressive subjects, like this one from the Venice Carnival.

In order to take shots such as this one with the camera handheld, you will need high-speed film (ISO 1000/31°) as well as a fast lens (f/1.4 was used here).

twice as long a shutter speed (greater danger of camera shake), or you have to load twice as fast a film. If the difference in maximum aperture is f/2.0 and f/4, as much as four times the amount of light is required!

A variable maximum aperture is given for many zoom lenses (f/3.5-4.5, for example). The opening of the iris diaphragm doesn't change, but the change in focal length affects the effective maximum aperture. This aperture difference is kept as small as possible by means of clever construction methods. Many zoom lenses, like the EF 100-300mm,f/5.6, now have a single fixed maximum aperture.

We have already covered the point that the lens aperture is not only interesting in terms of the speed of a lens, but also controls the

Special light atmospheres can and should be intensified by adjusting the exposure accordingly. In one case the exposure was made without exposure compensation - in the knowledge that the large amount of sky and sun would lead to an underexposure. But in this case this corresponds to the impression the scene actually gives. The other shot was deliberately overexposed slightly, in order to emphasize the gentle lighting and the pastel colours.

The quality of the lens is only one factor that contributes to a good photograph. Light and shade, colours, composition, etc., play an equally important role.

exposure and the depth of field. By stopping down the aperture, less light reaches the film, so in conjunction with the shutter speed, this allows the exposure to be controlled accurately. This is done by the automatic program of the EOS 100/Elan.

At the same time, the depth of field increases as the aperture is stopped down. We can influence this effect very precisely by means of the **depth** program and once the depth of field zone is set, the EOS 100/Elan will calculate by how much the aperture needs to be stopped down. You can see for yourself in the viewfinder of the EOS 100/Elan that different focal lengths really do produce different depth of field zones by comparing telephoto and wide-angle view-finder images in terms of their depth of field.

Lenses for the EOS 100/Elan

On the following pages you will find an overview and short description of the lenses currently available for the EOS 100/Elan. You will notice that some lenses appear to exist in duplicate. There are positive as well as negative reasons for this. If the lens has an 'L' in its name, this is an advantage, but buying it will have a negative effect on your bank balance. Its construction will include elements made of UD or fluorite glass with particularly low colour dispersion, increasing image sharpness.

Incidentally, a lens hood and UV absorption filter are almost obligatory with every lens. They protect the lens from damage, reduce flare and haze. But be careful with some of the EF zooms, which move the front element and the filter mount because the lens hood may restrict focal length adjustment.

Wide-angle lenses - a spectacular view of things

All the wide-angle lenses for the EOS 100/Elan are so-called retro-focus constructions. The reason for this is that a minimum distance between bayonet and film plane must always be maintained to allow for necessary mirror movement. This is achieved with constructions whose diameter is greater than their focal length to allow shorter focal lengths despite a backfocus of 42mm. These retro-focus lenses combine negative front elements and positive rear elements. A virtual image is produced at the location of the nominal focal length, and this is then projected back onto the film by a further element construction.

EF wide-angle lenses range between 14mm and 35mm focal length, covering angles of view from 180° and 84°, and the vast majority are equipped with so-called 'floating elements'.

Selecting focal lengths in the wide-angle range is not easy, because of the number of lenses on offer. It's best to start with the moderate focal lengths before going on to the extremes. The spectacular effects that can be achieved with very short focal lengths quickly become tiresome.

The EF 14mm,f/2.8 L USM is a high performance wide-angle lens that uses nearly everything that's good and expensive. It uses an aspherical element to largely correct distortion, internal focusing to correct the astigmatism, and 'floating elements' to gain an overall increase in the optical quality at all subject distances.

This lens has a clever practical feature in addition to these technical highlights that promise excellent optical quality. Instead of a motorized ring it has a mechanical system for manual focusing which means on one hand that no power is required for manual focusing, but on the other, focus can be set manually even in autofocus mode. This can be a great advantage in some situations.

This focal length needs to be used carefully, as the distinct wide-angle effect - an over-emphasis of details in the foreground - can easily become tiresome. It is particularly suitable for panoramic shots, interiors and, above all, effect shots. But only acquire one if you've moderate wide-angle focal lengths already in your system. Because of the extreme 114° angle of view, lines outside the image centre are reproduced barrel-shaped. This isn't a fault, but is due to optical laws.

The EF 15mm,f/2.8 Fisheye is an extreme wide-angle lens with an angle of view of 180°, which fills the entire film format. If you stretch your arms out to the side you will be able to see the immense angle of view of this lens. In fact, the angle of view is so wide you have to be careful not to get the tips of your shoes in the shot. And if the sun is behind you or coming from the side, it is almost certain that your shadow will appear in shot. Because of the wide angle of

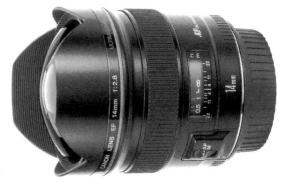

Canon EF
14mm,f/2.8 L USM

116

view you need to pay particular attention to avoid getting unwanted details in shot.

Because of optical laws, all wide-angle lenses reproduce straight lines as lines that bend outwards - this effect becomes stronger the

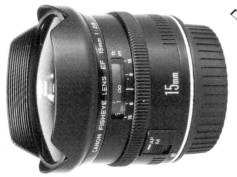

Canon EF 15mm,f2.8 Fisheye

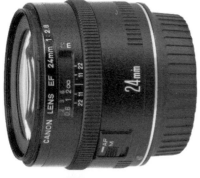

Canon EF 24mm,f/2.8

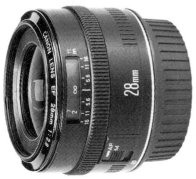

Canon EF 28mm,f/2.8

closer the lines are to the image edge. Only straight lines running exactly through the image centre are also reproduced as straight lines. This effect is not an inherent fault of wide-angle lenses, but optical law. Barrel-shaped distortion is particularly pronounced on the Fisheye, the shortest focal length in the EF range. This is a lens whose extreme effect quickly becomes tiresome if used thoughtlessly. It is suitable for panorama shots, tight interior shots, and especially for effect shots, as it lends a touch of drama.

The Fisheye is well suited for effect photography. Used thoughtfully, it can produce excellent photographs, but used to excess, the effect very quickly becomes tiresome. This lens is therefore only to be recommended to the ambitious amateur who already owns a good lens range and is looking for a specialist lens to suit certain occasions.

With an angle of view of 84°, the EF 24mm,f/2.8 is the wide-angle lens in the EF range which offers great depth of field even at its maximum aperture and allows impressive wide-angle perspectives. The bending of straight lines at the image edge is still noticeable, but is far less pronounced than with the Fisheye.

The EF 28mm,f/2.8 is almost free of distortion. It is compact, fast and offers top optical quality thanks to an aspherical lens. If your zoom lens does not cover this focal length setting, this is the first wide-angle lens you should buy. Unlike the 35mm wide-angle, the effect it produces is noticeably different from a standard lens. It is a proper wide-angle lens, but does not produce an exaggerated effect.

Canon EF 35mm,f/2.0

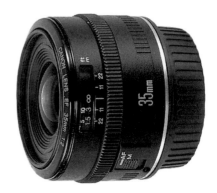

The EF 35mm,f/2.0 is extremely fast. This focal length can not really be considered typical wide-angle, it almost falls within the standard focal length category. But its greater depth of field and wide angle of view of 63° mean it is more suitable than a standard lens in many situations. It is an ideal snapshot lens.

Standard, but not boring

The term 'standard lens' refers to a lens with an angle of view of 46°. It's interesting to know that roughly the same angle of view results if a picture is viewed from a normal distance - usually the diagonal of the image. Shooting and viewing angle are then largely the same.

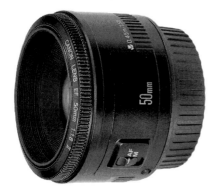

Canon EF 50mm,f/1.8

The EF 50mm,f/1.8 is extremely compact and fast but its greatest advantage is its low price. Compared to zoom lenses it is relatively fast, but for a standard lens it is a touch slow. A standard speed would be around f/1.4 or f/1.2 - these are available in the Canon lens range, but lack the autofocus facility.

Canon's EF 50mm,f/1.0 L USM, on the other hand, is a high point of lens technology. It is the fastest lens available for a 35mm SLR camera. Two aspherical elements and special glasses with a high refractive index practically eliminate all spherical aberration usually found in extremely fast lenses. 'Floating elements' ensure that the optical quality remains consistently high at every shooting distance. It is a real specialist lens - if only because of its very high

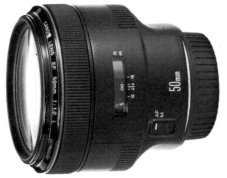

price - and is well suited to available light photography. The high maximum speed also allows special focusing effects because when used at f/1.0 the depth of field is almost zero, allowing great emphasis to be placed on certain subject details, perhaps the eyes in a portrait shot, or a single leaf.

Macro lenses - to capture the world at your feet

The photographer has two options for venturing into the close-up range with the EOS 100/Elan. There is the EF 50mm,f/2.5 Macro and the EF 100mm,f/2.8 Macro. Both lenses have a very long focusing range. The EF 50mm,f/2.5 Macro allows shots down to a ratio of 1:2, or half life size, without the need for further accessories. The EF 100mm,f/2.8 Macro comes with a magnification ratio as high as 1:1 as standard.

The minimum focusing distance is, of course, by no means the only reason that makes these lenses well suited for close-ups. Their entire optical construction is designed for top quality. A macro lens must be suitable for copying, and this imposes special demands on the lens. It must have a complete lack of distortion, a flat field focusing, extremely true colours and excellent resolution to allow a subject like a stamp or map to be reproduced accurately. All this

120

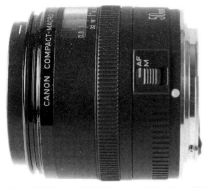

Canon EF 50mm,f/2.5 Macro and Life-Size-Converter

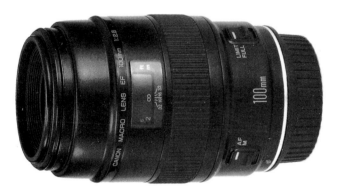

Canon EF 100mm,f/2.8 Macro

makes for an outstanding lens, which is also excellent for normal photography.

'Life-Size-Converter' is a very descriptive name for the optical attachment available as an accessory for the EF 50mm,f/2.5. The Life-Size-Converter allows continuously adjustable reproduction ratios between 1:4 and 1:1.

The best choice of focal length for a macro lens depends on the application. If you work predominantly with a repro stand, the shorter focal length is recommended because the stand has a

limited length, and you want to cover the largest subject area possible. On the other hand, a longer focal length is always advisable for outdoor shots, because the distance between front element and subject is greater. This has advantages in terms of lighting as the photographer's shadow doesn't fall on the subject so readily. Small animals like insects are happier about your photographic activities when you shoot from further away.

Romance created by the Softfocus lens

The 135mm,f/2.8 Softfocus is an interesting lens. It allows you to reduce its carefully calculated quality in a good cause. If you own such a lens, you can see for yourself the fatal effects of uncorrected spherical aberration. The Softfocus lens gives a softfocus effect because the degree of spherical aberration is changed deliberately. In effect you're playing with a reproduction fault to create a special effect.

Softfocus is often used for portraits, to conceal skin imperfections and small wrinkles. But the Softfocus lens is also suitable for any other subject that benefits from a reduction in their sharpness. A landscape, an autumnal forest, a nude or a still life are all examples whose effectiveness may be increased in this way. The subject will appear lighter and more impressionistic.

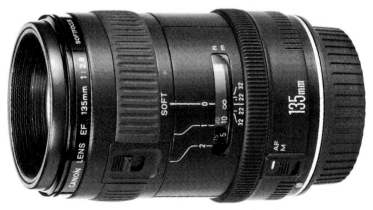

Canon EF 135mm,f/2.8 Softfocus

But it would be doing the Softfocus an injustice to consider it merely as a bad lens. In its basic setting, it is a highly corrected lens giving top optical performance and can easily be used as a normal, sharp telephoto. The option of influencing the reproduction of sharpness is an extra benefit.

But there are also different cheap softfocus options, from the nylon stocking or a glass disk with vaseline, to a screw-on filter. So is this special lens worthwhile? As they are cheaper, these other aids are certainly a better bet for first exploration of this effect, but all are very dependent on the lens aperture. The effect is most pronounced at full aperture and decreases as the lens is stopped down.

> **Tip:** For first experiments with a softfocus effect you can carefully breathe on the front element of any lens, and then quickly take the shot before the lens clears. The effect can be controlled to some extent by breathing on the lens more or less strongly, and by changing the time allowed to elapse before the shot is taken.

With the Softfocus lens the effect can be regulated independently from the aperture, by directly adjusting the correction of the lens. But this effect is almost completely cancelled from f/5.6 onwards, so you need to ensure that lighting conditions aren't too bright when using program modes or the automatic program will select small apertures. In fact it would be better to use aperture priority with the EOS 100/Elan to ensure a good result.

Light giants in the telephoto range

The long focal length telephotos for the EOS 100/Elan are real delicacies. They are all extremely fast, and most of them are equipped with aspherical elements and special type of glass. Like almost all fixed focal lengths for the EOS 100/Elan, all the telephoto lenses are simply optical masterpieces.

Take, for example, the EF 85mm,f/1.2 L USM, whose construction includes an aspherical element, 'floating elements' and special glass. This expensive construction eliminates almost all spherical

Canon EF 85mm,f/1.2 L USM

aberrations, reduces stray light and flare as well as barrel-shaped distortion to provide consistently high optical quality across the whole setting range. When the lens is used at its maximum aperture, the depth of field is extremely shallow - a fact which can be put to good use in picture composition. But you should ensure that the focus is set precisely, or change to manual focusing. For portraits, a great forte of this lens, the iron rule is to focus on the eyes. You must watch out for this, as the depth of field is so shallow that even the nose will already be unsharp.

Apart from the EF 85mm,f/1.2 L USM, the EF 100mm,f/2.0 USM is another typical portrait telephoto lens. Thanks to internal focusing, very little power is required for focusing, and the ultrasonic motor can travel the entire setting range from infinity to 0.9m in just 0.4sec!

The EF 200mm,f/2.8 L USM is designed as an inexpensive high performance telephoto with a wide maximum aperture. Its innovative optical construction compensates for the spherical aberration when focusing distance is changed, substantially improving the optical quality at medium and close range. Two of the nine elements in the seven-group system are made from UD anomalous dispersion glass which reduces chromatic aberrations. The ultrasonic motor and internal focusing allow very fast focusing in autofocus mode. Manual focusing is done via a mechanical ring.

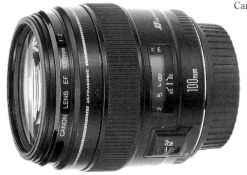

Canon EF 100mm,f/2.0 USM

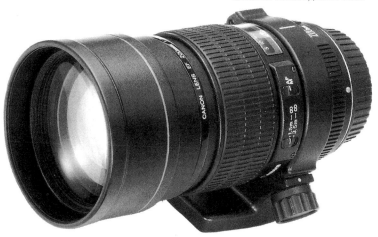

Canon EF 200mm,f/2.8 L USM

The EF 200mm,f/1.8 L USM is as fast as a standard lens, and it is great for available light photography in enclosed spaces. You will find subjects for this lens at the circus, theatre or opera, and at funfairs. Two extenders can also be used to increase the focal length and scope.

The EF 300mm,f/2.8 L USM is the right telephoto lens for sports and animal photography. Its high speed allows fast shutter speeds to capture fast movement but priced at around £2300 it isn't exactly cheap.

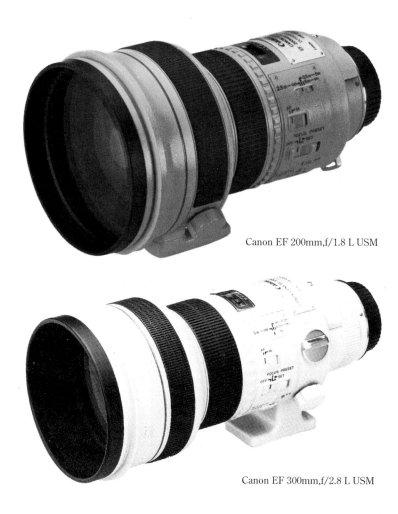

Canon EF 200mm,f/1.8 L USM

Canon EF 300mm,f/2.8 L USM

The EF 300mm,f/4.0 L USM is a noticeably cheaper alternative. While its optical performance is comparable, it is one stop slower, and costs less than £700. Two UD glass elements reduce chromatic aberrations, and internal focusing The integral ultrasonic motor ensure fast focusing although manual focusing of this lens is possible using the mechanical focusing ring. This is necessary when the lens is used with the 2x extender.

The EF 400mm,f/2.8 L USM is an extremely fast and expensive, long focal length telephoto but thanks to its ultrasonic motor it can travel the entire setting range in a mere 0.7sec. Two UD elements with extremely low dispersion ensure excellent correction of colour faults. The lens allows you to preselect focusing distance, which can then be set very quickly - handy for sports photographers.

The EF 600mm,f/4.0 L USM allows you to capture extreme telephoto shots, almost with the camera hand-held. Its speed is less of a limitation than its weight of 6kg.

Two extenders are available for these giants. They are specially designed for fixed focal length lenses from 200mm to 600mm,

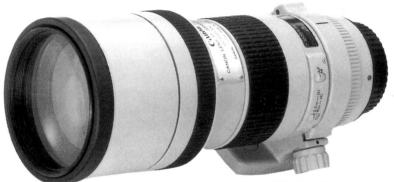

Canon EF 300mm,f/4.0 L USM

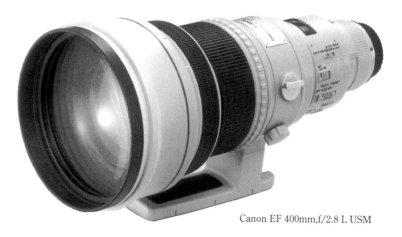

Canon EF 400mm,f/2.8 L USM

127

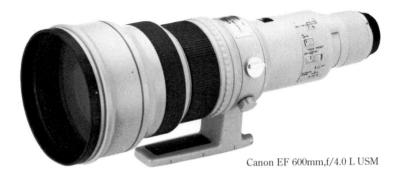

Canon EF 600mm,f/4.0 L USM

increasing their focal length by a factor of 1.4 and 2 respectively. This means that the Canon lens range is increased by several additional focal lengths, and a 1200mm,f/8.0 lens (600mm,f/4.0 plus 2x extender) is quite a good lens.

The example of the 1200mm,f/8.0 will also illustrate the disadvantage of the extender: as the focal length increases, the speed decreases, because the lens aperture cannot increase. The 1.4x extender reduces the effective aperture by exactly one stop, the 2x extender by as much as two stops. This means that only half or one-quarter of the amount of light will reach the film when an extender is used.

But the disadvantage of decreasing speed can be completely ignored with the three telephoto lenses in question because they are so extremely fast in the first place. So you can get very respectable values even with an extender and gain a 280mm,f/2.5 lens (200mm,f/1.8 plus 1.4x extender) or a 400mm/f/3.6 lens (200mm,f/1.8 plus 2x extender). The same applies to other focal lengths, where extenders can be used without restriction, to turn one lens into two or even three different focal lengths.

But unfortunately tele-converters also increase optical flaws, as basically, they only magnify the image created by the prime lens. This is why, when using extenders, you should stop down the lens by two stops if possible to allow it to work in the range where optical quality is best. Canon's extenders are specifically designed for the telephoto focal lengths, which ensures that lens and converter can form an harmonious optical system. The following combinations are possible:

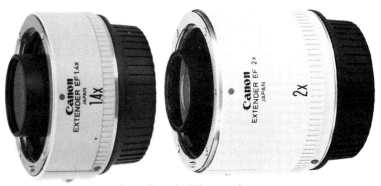

Canon Extender EF 1.4x and 2.0x

Lens	+ 1.4x extender	+ 2x extender
200mm,f/1.8 L	280mm,f/2.5	400mm,f/3.6
300mm,f/2.8 L	420mm,f/3.9	600mm,f/5.6
400mm,f/2.8 L	560mm,f/3.9	800mm,f/5.6
600mm,f/4.0 L	840mm,f/5.6	1200mm,f/8.0

Please note that the 2x extender in conjunction with the EF 300mm,f/4.0 and the EF 600mm,f/4.0 only allows manual focusing.

Zoom lenses: variable in every way

Canon has really splashed out with a wide range of variable focal lengths for the EOS 100/Elan, leaving hardly any stone unturned. The range covers focal lengths between 28mm and 300mm almost without gaps.

Canon's EF 20-35mm,f/2.8 L is an extreme wide-angle zoom, whose price tag becomes relatively cheap when you consider that it covers four popular wide-angle focal lengths; 21mm, 24mm, 28mm and 35mm. And remember it's a particularly well-corrected 'L' version, sporting internal focusing, an aspheric element and 'floating elements' which show that the optical designers have done everything in their power to realize top optical quality.

Canon EF
20-35mm,f/2.8 L

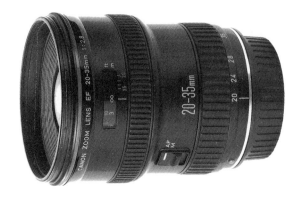

Canon EF
28-70mm,f/3.5-4.5

Canon EF 28-80mm,f/2.8-4 L USM

130

Canon EF 28-80mm,
f/3.5-5.6 USM

The EF 28-70mm,f/3.5-4.5 covers wide-angle and standard focal lengths. As long as you are not looking for extreme wide-angle effects, this lens is very good in the wide-angle range. Add a telephoto zoom to this one, and your equipment will be complete.

The EF 28-80mm,f/2.8-4 L USM is another top-quality lens, designed for speed and optimum performance. But this quality has its price, and it costs around four times as much as the slower EF 28-80mm,f/3.5-5.6 USM.

This lens was designed specifically for your camera, the EOS 100/Elan. It matches the low operating noise and the integral flash of this camera. Practically silent operation is achieved with an ultrasonic motor, and manual focusing is possible without switching off the autofocus. It is also shaped so that it doesn't cast a shadow when using the integral flash of the camera, even when shooting down to 1m.

Excellent optical correction and a light, compact design is achieved by using a new type of aspherical element. The 'aspherical replica element' is produced by coating a spherical element with a UV-hardened layer of plastic that gives an aspherical surface. A further feature is the light baffle which moves between the second and third group, effectively suppressing flare across the entire focal length range.

The 28mm to 80mm focal length range of the two zoom lenses mentioned above covers a wide variety of photographic situations. It is completely adequate in the wide-angle range, as long as you

Canon EF 35-70mm,f/3.5-4.5

Canon EF 35-80mm,f/4-5.6

don't want to take extreme wide-angle shots. 28mm is a focal length very often used for landscape shots as well as interiors. 80mm, at the other end of the scale, is a very nice, moderate telephoto focal length that is as well suited to portraits as it is for shooting details from a distance.

The EF 35-70mm,f/3.5-4.5 is a real 'standard zoom' which can fully replace a standard lens if you disregard its slightly slower

It's always worth experimenting in photography. Everything was done wrong here: shooting with artificial light slide film in daylight, and with the camera handheld despite the slow shutter speed - with the result that nothing is in focus and the colours are all wrong. But the photographs are still interesting.

Canon EF
35-105mm,f/3.5-4.5

speed. Only marginally heavier than a fixed focal length, and very compact, it covers a moderate focal length range. 35mm can produce panoramic shots, but without an overemphasized wide-angle effect, while 70mm allows you to concentrate on detail. It is a zoom which allows few mistakes in terms of picture composition, and can be particularly recommended as a universal zoom for the beginner. It is available in two versions, of which one, the EF 35-70mm,f/3.5-4.5 A does without a manual focus facility.

The EF 35-80mm,f/4-4.5 and EF 35-80mm,f/4-5.6 zoom lenses cover a focal length range from wide-angle to portrait telephoto, and are often bought as 'standard zooms' instead of the standard lens. The slower version is very inexpensive and was originally supplied with the EOS 700, although it can be used with the EOS 100/Elan without any restrictions.

The EF 35-105mm,f/3.5-4.5, its slightly slower and cheaper cousin the EF 35-105mm,f/4.5-5.6, and the EF 35-135mm,f/4-5.6 USM are zoom lenses which cover a range from wide-angle to medium telephoto. If you have one of these lenses, you won't miss out on much. They are ideal focal lengths if you want to cover the widest

A telephoto setting around 100mm is suitable for portraits and photographing people, to achieve a balanced reproduction of facial features and proportions.

possible photographic spectrum with minimum expenditure. You probably won't need any more focal lengths but if you do, fixed focal lengths can be excellent complements to one of these zooms in the wide-angle and telephoto range.

The EF 35-105mm,f/4.5-5.6 is specifically intended for the small, light EOS 1000/Rebel and 1000F/Rebel S, but has a number of features that also make it an interesting lens to use with the EOS 100/Elan. Apart from its attractive price, there is the aspherical element which compensates for optical faults that would otherwise appear when focusing or zooming. The aspherical element also corrects edge quality. Overall, this lens delivers a very good optical performance with razor-sharp, high contrast results and minimal flare the norm. Finally, the aspherical element also allows it to be particularly compact. The alternative EF 35-105mm,f/3.5-4.5 is almost twice as fast, but only a touch more expensive.

There are hardly any new lenses from Canon that are not equipped with an aspherical element. The EF 35-135mm,f/4-5.6 USM has one too, to compensate for spherical aberration. Only the second optical group is moved for focusing. This achieves faster focusing and allows you to manually adjust the focusing at any time - even in autofocus mode. Fitting filters has been simplified by a non-rotating front element, and a wide zoom range means that the

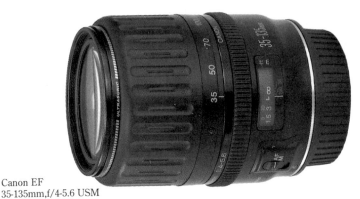

Canon EF
35-135mm,f/4-5.6 USM

lens is an ideal universal zoom. It covers a range from moderate wide-angle to moderate telephoto, so that there are many occasions, like family outings, when you don't need any other lens and so your outfit stays small and handy.

The EF 70-210mm,f/3.5-4.5 is simply **the** standard zoom. It was this focal length range that began the victorious progress of variable focal lengths, and it is still very popular today. Combined with the EF 28-70mm,f/3.5-4.5, it represents a complete focal length range from true wide-angle up to medium telephoto. It covers all telephoto focal lengths for everyday photography: 85-105mm for

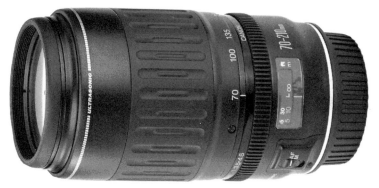

Canon EF 70-210mm,f/3.5-4.5 USM

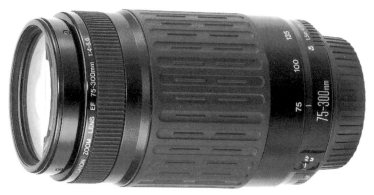

Canon EF 75-300mm,f/4-5.6

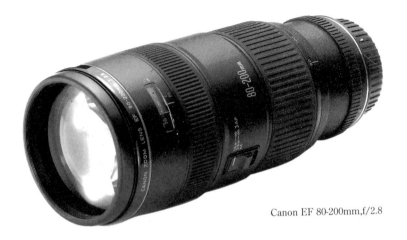

Canon EF 80-200mm,f/2.8

Canon EF 50-200mm,f/3.5-4.5

Canon EF 100-300mm,f/5.6 L

portraits, 135mm for a noticeable telephoto effect, and 200mm with its shallow depth of field and ability to separate subjects from the background. For focusing the fourth optical group is moved independently from the rest of the system, which makes for faster focusing and easier filter fitting as the front element doesn't move. Manual focusing is also possible in autofocus mode.

The EF 75-300mm,f/4-5.6 excels with its wide focal length range, from moderate telephoto creeping up to the border of extreme telephoto territory. It is just as suitable for portraits as it is for capturing exciting telephoto shots from great distances. Despite the range on offer, its particularly low weight of 500g is thanks to a particularly light type of glass that's about one-third lighter than conventional glass.

The fast EF 80-200mm,f/2.8 L zoom covers the popular telephoto focal lengths of 85mm, 100mm, 135mm and 200mm, and its speed matches that of the equivalent fixed focal lengths. Three elements with UD glass (Ultra-Low Dispersion) prevent chromatic aberration, and internal focusing allows fast and accurate working.

If you choose the EF 50-200mm,f/3.5-4.5, the standard lens becomes superfluous, unless you need high speed. This lens covers an angle of view between 46° and 12°, fully covering

Canon EF 100-300mm,f/4.5-5.6 USM

standard and telephoto ranges. Longer focal lengths than this are only necessary for specialist applications like animal and sports photography.

The lens also sports a red ring and the suffix 'L'. This version utilizes elements with particularly low dispersion, whose advantages have already been fully covered in the chapter *Light giants*. As with the 100-300mm,f/5.6 L, the 'better' lens version only makes sense if you really do have the highest quality requirements. As a result, these lenses are really aimed at the professional photographer. But you should consider buying the more expensive option if you put together slide shows on large screens and for big audiences, or if you're aiming for 20x24in exhibition prints. But it would be completely pointless to use such a lens for enprint size shots for the family album.

The EF 100-300mm,f/4.5-5.6 USM and EF 100-300mm,f/5.6 L are telephoto zooms of the highest calibre. The former is the faster and lighter model, but the latter is designed to deliver maximum optical quality. Both lenses are an excellent way of extending your focal length range if you started with a smaller zoom like the EF 35-70mm,f/3.5-4.5, for example, or even with a standard lens.

Tilt-and-shift lenses

The TS lenses for the EOS 100/Elan are a real speciality. Three different focal lengths are available: TS-E 24mm,f/3.5, TS-E 45mm,f/2.8 and TS-E 90mm,f/2.8.

Thanks to their wide image circle, all three lenses can be shifted (up to 11mm parallel to the optical axis) and tilted (+/- 8°). They therefore allow not only the correction of the perspective, but also meet the Scheimpflug condition which states that a plane is reproduced sharply if subject, lens and image planes intersect at a common line.

What does this mean in practical photographic terms? Normally only a very limited plane, exactly parallel to the back of the camera, is reproduced in perfect focus, as depth of field is more or less imagined. It is achieved by reducing the size of the circles of unsharpness to a point that the unsharpness is no longer recognized by the eye. Not so with the TS lens. Its optics can be tilted by +/- 8°, so that top focus can be placed on a plane that does not have

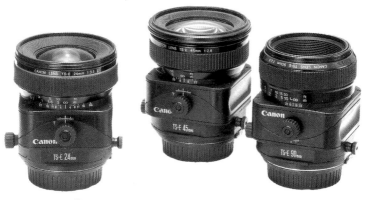

Canon TS-E 24mm,f/3.5 L, TS-E 45mm,f/2.8 and TS-E 90mm,f/2.8

to be parallel with the film plane. Together with the depth of field, the area of focus can therefore be carefully controlled. This doesn't necessarily mean keeping the largest area possible in focus, it also allows the area of focus to be kept very narrow.

In view of their high price, the purchase of such a lens needs to be carefully considered. They don't achieve spectacular effects. A tilt of 8° is not very much, as the plane must only be moved from the parallel by a small amount in order to still be able to satisfy the Scheimpflug condition. The height increase of the tilt can be calculated:

Hm = Dm (A/F)

Hm = increase in height in metres
Dm = shooting distance in metres
A = lens adjustment in millimetres
F = focal length in millimetres

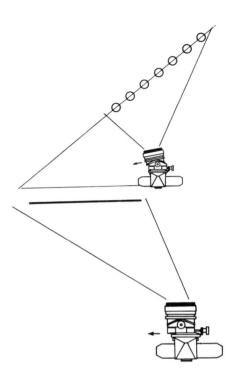

The TS-E lenses can be tilted by 8°, in order to capture sharply planes that do not run parallel with the film plane (Scheimpflug condition). These lenses can also be shifted in order to be able to capture different sections of the subject from the same shooting position. This is useful for eliminating intrusive foregrounds or for shooting tall buildings without distortions in the perspective.

At a shooting distance of five metres, using the maximum shift, you can therefore gain 2.25 metres with the TS-E 24mm,f/3.5.

As the adjustment of the optical system changes the course the light takes to the autofocus sensors, automatic focusing is not possible, and the three TS lenses have to be focused manually. The adjusting lens movement can also produce incorrect exposure, so the exposure should be determined first.

'A' lenses

The 'A' lenses, for example the EF 100-200mm,f/4.5 A, are no longer available from Canon, but you may come across one second-hand. This lens is only suitable for automatic focusing, so the

142

photographer no longer has the opportunity to switch to manual mode and focus manually in critical situations. You can check where this might be useful if you go back to the chapter on the autofocus system, but you have to decide for yourself whether it's worth sacrificing the manual option for the sake of price.

FD-EF lens converter

If you want to use lenses from the 'FD' series (the series without autofocus) with your EOS 100/Elan, you can do so by using the FD-EF lens converter. This allows a number of FD series telephoto lenses with the EOS cameras, but the converter was principally developed for focal lengths of 300mm or more, which are increased by a factor of 1.26 when the converter is used. This reduces the effective aperture by two-thirds of a stop. Obviously, only manual focusing is possible and you need to select either manual exposure or aperture priority modes on your EOS 100/Elan.

In view of the very wide range of EF lenses available for the EOS 100/Elan nowadays, the converter will probably only be of interest to photographers who still have FD lenses and want to use those for a limited period of time until they can switch to the EF variant. The restrictions (manual aperture selection, aperture priority) are considerable.

The converter is suitable for the following FD lenses: FD 200mm,f/1.8 L, FD 200mm,f/2.8 L (RF), FD 300mm,f/2.8 L, FD 300mm,f/4.0, FD 400mm,f/2.8 L, FD 400mm,f/4.5, FD 500mm,f/4.5 L, FD 600mm,f/4.5, FD 800mm,f/5.6 L, FD 50-300mm,f/4.5 L, FD 85-300mm,f/4.5, FD 150-600mm,f/5.6 L.

Lens selection

We have discussed in some detail corrective measures, speed, the pros and cons of variable and fixed focal lengths, and the lenses available, so choosing suitable lenses should now become easier. The one thing that always needs to be considered is the intended application.

The EF lens range in particular usually includes several alternatives of different speed and quality, and it doesn't always have to be

Canon EOS Lens System

Lens	AF Actuator[1]	Angle of View	Lens Construction	Minimum Aperture	Closest Focusing Distance (m)	Filter Diameter (mm)	Length x Max. Diameter (mm)	•	Weight (g)
EF 14 mm f/2.8L USM	USM	114°	13/10	22	0.25 ~ ∞	Filter Holder	89 x 77	•	560
Fish-Eye EF 15 mm f/2.8	AFD	180°	8/7	22	0.2 ~ ∞	Filter Holder	62.2 x 73	•	330
EF 24 mm f/2.8	AFD	84°	10/10	22	0.25 ~ ∞	58	48.5 x 67.5	•	270
EF 28 mm f/2.8	AFD	75°	5/5	22	0.3 ~ ∞	52	42.5 x 67.4	•	185
EF 35 mm f/2.0	AFD	63°	7/5	22	0.25 ~ ∞	52	42.5 x 67.4	•	210
EF 50 mm f/1.0L USM	USM	46°	11/9	16	0.6 ~ ∞	72	81.5 x 91.5	•	985
EF 50 mm f/1.8 II	MM	46°	6/5	22	0.45 ~ ∞	52	41 x 68.2	•	130
EF 50 mm f/2.5 Compact-Macro	AFD	46°	9/8	32	0.23 ~ ∞	52	63 x 67.6	•	280
Life Size Converter EF	‒‒	‒‒	4/3	‒‒	0.24 ~ 0.42	‒‒	34.9 x 67.6	•	160
EF 85 mm f/1.2L USM	USM	28° 30'	8/7	16	0.95 ~ ∞	72	84 x 91.5	•	1,025
EF 100 mm f/2.0 USM	USM	24°	8/6	22	0.9 ~ ∞	58	73.5 x 75	•	460
EF 100 mm f/2.8 Macro	MM	24°	10/9	32	0.31 ~ ∞	52	105.3 x 75	•	650
EF 135 mm f/2.8 Softfocus	AFD	18°	7/6	32	1.3 ~ ∞	52	98.4 x 69.2	•	390
EF 200 mm f/1.8L USM	USM	12°	12/10	22	2.5 ~ ∞	48 Drop-in	208 x 130	•	3,000
EF 200 mm f/2.8L USM	USM	12°	9/7	32	1.5 ~ ∞	72	136.2 x 83	•	790
EF 300 mm f/2.8 L USM	USM	8°15'	9/7	32	3 ~ ∞	48 Drop-in	253 x 125	•	2,855
EF 300 mm f/4.0 L USM	USM	8°15'	8/7	32	2.5 ~ ∞	77	213.5 x 90	•	1,165
EF 400 mm f/2.8 L USM	USM	6°10'	11/9	32	4 ~ ∞	48 Drop-in	348 x 167	•	6,100

Lens	Motor	Angle of view	Elements/Groups	Min. aperture	Focus range (m)	Filter (mm)	Dimensions (mm)		Weight (g)
EF 600 mm f/4.0 L USM	USM	4°10'	9/8	32	6 ~ ∞	48 Drop-in	456 x 167	•	6,000
EF 20-35 mm f/2.8 L	AFD	94° ~ 63°	15/12	22	0.5 ~ ∞	72	79.2 x 89	•	570
EF 28-80 mm f/2.8-4.0 L USM	USM	75° ~ 30°	15/11	22	0.5 ~ ∞	72	119.5 x 84	•	945
EF 28-80 mm f/3.5-5.6 USM	USM	75° ~ 30°	10/9	22 ~ 38	0.5 ~ ∞	58	77.5 x 72	•	330
EF 35-80 mm f/4.0-5.6	MM	63° ~ 30°	8/8	22 ~ 32	0.37 ~ ∞	52	61 x 68.6	•	180
EF 35-105 mm f/4.5-5.6	MM	63° ~ 23°30'	13/12	22 ~ 27	0.85 ~ ∞	58	63.3 x 70.6	•	280
EF 35-135 mm f/4.0-5.6 USM	USM	63° ~ 18°	14/12	22 ~ 32	0.75 ~ ∞	58	86.4 x 72	•	425
EF 70-210 mm f/3.5-4.5 USM	USM	34° ~ 11°20'	14/10	22 ~ 27	1.2 ~ ∞	58	121.5 x 73	•	550
EF 75-300 mm f/4-5.6	MM	32°11' ~ 8°15'	13/9	32 ~ 45	1.5 ~ ∞	58	122 x 73.8	•	500
EF 80-200 mm f/2.8 L	AFD	30° ~ 12°	16/13	32	1.8 ~ ∞	72	185.7 x 84	•	1,330
EF 80-200 mm f/4.5-5.6	MM	30° ~ 12°	10/7	22 ~ 27	1.5 ~ ∞	52	77.8 x 71.2	•	275
EF 100-300 mm f/5.6 L	AFD	24° ~ 8°15'	15/10	32	1.5 ~ ∞	58	166.6 x 75	•	695
EF 100-300 mm f/4.5-5.6 USM	USM	24° ~ 8°15'	13/10	32 ~ 38	1.5 ~ ∞	58	121.5 x 73	•	540
TS-E 24 mm f/3.5 L	--	84°	11/9	22	0.3 ~ ∞	72	86.7 x 78	•	570
TS-E 45 mm f/2.8	--	51°	10/9	22	0.4 ~ ∞	72	90.1 x 81	•	645
TS-E 90 mm f/2.8	--	27°	5/6	32	0.5 ~ ∞	58	88 x 73.6	•	565
Extender EF 1.4 x	--	--	5/4	--	--	--	27.3 x 67.6	•	210
Extender EF 2 x	--	--	7/5	--	--	--	50.5 x 67.6	•	240
Extension Tube EF 25	--	--	--	--	--	--	27.3 x 67.6	•	125

*1 AFD = Arc Form Drive, USM = Ultrasonic Motor, MM = Micro Motor.

145

the best, and therefore the most expensive, version you need to choose.

If, for example, a lens is to be used for press work on a daily newspaper, then the simplest and slowest version will always be sufficient, as you can easily use a fast film. The coarse printing screen will obscure all fine detail anyway, and the reproduced size is usually very small.

It's a different picture if theatre photography is to be the theme of a full-colour book or a slide show. In this situation the demands in terms of speed and quality will be very different. Let's leave the examples there. They simply show you that the use of the lens should always be carefully considered before buying, otherwise you might waste money on the one hand, or be unable to gain satisfactory results on the other.

In view of the multitude of optics described, I should also say that the best way to prevent mistakes is to add to your equipment step by step. The 15mm, f/2.8 Fisheye may sound an extremely exciting lens, but if you don't spend a lot of time studying extreme wide-angle photography and its possibilities, you will soon tire of this lens. A more moderate focal length - 28mm, for example - can be used far more frequently, and it will also help you find your own style. The Fisheye can come much later and, of course, the same applies to the telephoto range.

Flash photography doesn't necessarily mean doing without other light altogether. The combination of flash and ambient light can be particularly attractive; in this shot it has produced interesting wipe effects with sharp details.

Flash photography

The EOS 100/Elan has a small integral zoom flash unit with a guide number ranging from 12 to 17 depending on the reflector position. The unit switches on automatically in the fully automatic programs (green program, image zone shooting modes and bar-code program), when it is either too dark for shake-free shots, or when the evaluative metering system registers a backlight situation. The advantages of the integral flash unit are its invisibility, compactness and that it switches on automatically.

In program, shutter or aperture priority mode it only comes on if you press the flash pop-up button on the EOS 100/Elan, found at front and left of the top-plate.

Incidentally, you can activate an interesting function with this same button. When a small stylized eye is lit on the LCD panel and in the viewfinder, a small spotlight comes on before the shutter is released to dazzle your subject, making their pupils contract, and so reducing red-eye effect. The release of the shutter is delayed when the spotlight is selected and a small scale even appears in the viewfinder and on the LCD panel to countdown to the moment the shutter is released.

Because of the evaluative metering system, the EOS 100/Elan decides whether flash is required to fill in or light the shot completely. The flash unit does, of course, need to be switched on, otherwise the EOS 100/Elan will make a normal long exposure. But when the flash unit is switched on, and the centre of the viewfinder is substantially darker than the surroundings, the flash will fire at less than full capacity. The aperture/shutter speed combination is selected so that the background is exposed sufficiently, while the shutter speed does not exceed the permitted sync setting. At the same time flash output is controlled so it lights the centre of the frame with roughly the same brightness. If there isn't much contrast between the different metering zones and it is dark, then the flash is fired and lights everything in overall fashion.

System flash units

If you are using a TTL-controlled flash unit - whether a Canon system flash, or an adapted flash unit from a different manufacturer connected via an SCA adapter - then certain camera functions are set more or less automatically, depending on the selected flash program. Exposure is always measured automatically through the lens (TTL), a separate metering sensor measures the flash light reflected from the film surface, and the flash duration is controlled accordingly. The film speed set and any exposure compensation are, of course, taken into account.

The simple automatic flash program will usually be perfectly sufficient. The option of preselecting aperture or shutter speed is not to be scoffed at for special situations, but to do this successfully you will need to have an exact idea about the effect you want to achieve.

If the system flash unit is ready to operate, the EOS 100/Elan will set the following functions:

- The sync speed is controlled between 1/125sec and 30 seconds, depending on the program. The aperture is controlled and depends on the program and the shooting distance measured by the infra-red auxiliary light emitter on the flash unit.

- The flash symbol appears in the viewfinder when the flash is ready.

- Automatic fill-in flash in backlight.

- TTL measurement on the film surface, taking into account film speed and any exposure compensation.

- The flash can be synchronized for the first or second shutter curtain.

- For photography with the integral flash unit the shutter button is locked until the flash unit is fully charged.

- When using Speedlites, a long exposure is made if the flash unit is not yet charged, just as if no flash were connected.

- System flash units adjust the built-in zoom reflector to vary the angle of coverage to suit the current focal length.

The Speedlites

Five system flash units are available: the Speedlite 160E, specifically for EOS cameras without integral flash (EOS 850); this is of no interest to the EOS 100/Elan, as its functions are the same as those of the small integral EOS 100/Elan flash unit.

The Speedlite 200E (guide number 20), Speedlite 300EZ (guide number 28) and the Speedlite 430EZ (guide number 35) are more powerful options, and there is also the Macrolite ML3, designed specifically for macro photography.

In terms of performance the two large Speedlites don't differ very much - the 430EZ emits around one-and-a-half times more light than the smaller 320EZ. But the advantage of the slightly more powerful Speedlite 430EZ is its tiltable reflector, which allows indirect flash and offers a number of special functions. These include a strobe flash facility - up to 10 frames per second - so it can keep up with fast a motordrive. It can be powered by an external power source, the Transistor Pack E.

A useful feature on both units is the motor-controlled reflector that adjusts to the current focal length of the lens in a range between 28mm and 85mm. This means that the light output of the flash unit is always optimally adjusted to fall on the subject without unnecessarily wasting light.

Like all modern flash units, the Speedlites have a thyristor circuit which ensures that unused flash charge is not wasted, but stored for the next flash exposure. This spares the batteries and increases their lifespan. It also means that the flash recycling time is reduced dramatically, as the flash may just need a partial recharge if only some was used for the previous flash exposure.

The amount of energy required for each exposure depends on the following parameters: shooting distance, aperture, reflector position and film speed. If the shooting distance is close, the aperture wide and the film fast, the flash will use substantially less power compared to less favourable combinations. With shooting distances up to one metre and wide apertures, motorized flash photography becomes possible. The flash unit is then recharged so quickly that it can keep up with the integral motor for a number of flashes, providing the condenser is fully charged.

The flash performance is strongly dependent on the position of the zoom reflector, both in terms of the adjustment to suit the

Canon Speedlite 200M

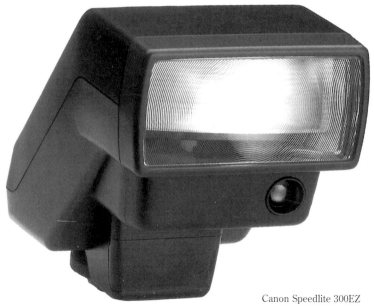

Canon Speedlite 300EZ

current focal length and as far as upward tilting is concerned. As the subject area to be illuminated is reduced, and the light concentrated, performance increases with longer focal lengths.

If the reflector is tilted upwards (possible on the 430EZ only), performance is reduced substantially. Film speed, shooting distance and reflector position are, of course, interdependent. Greater shooting distances and/or greater stopping down are possible with a fast film, while smaller distances allow narrower lens apertures, and so on.

Macro-Ringlite ML3

The ring flash unit Macro-Ringlite ML3, which has a guide number of 11, allows almost shadow-free frontal lighting. It is specifically developed for the EOS range, and the TTL flash metering system proves particularly helpful in the close-up and macro range, as exposure correction factors are automatically taken into account. The ring flash unit can light the subject very evenly which can be boring. Its great advantage is the clear rendering of detail.

If you want to create more interesting lighting effects, you can switch off one of the two flash tubes, to let light fall from either the left or right. The ring flash unit has a modelling lamp to aid focusing and composition, and this lights up for approximately 20 seconds.

If you buy the relevant TTL adapters, the ring flash unit can make an interesting combination with the Speedlite 300EZ or 430EZ. The illumination in the macro range can then be varied in many ways, using both units and the TTL cords. Incidental lighting, side lighting, transillumination, backlighting, and so on, are all possible. If necessary, the relatively high output of the Speedlite can be reduced by means of a diffuser which, at its simplest, can even be a paper tissue. Thanks to the TTL metering system there are no problems in determining the exposure.

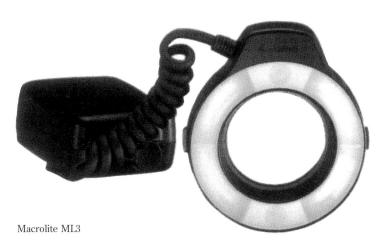

Macrolite ML3

Number of flashes and recycling time

The selection of a suitable power source is particularly important when you are looking for fast recycling times and a high number of flashes per charge. How various power sources differ is demonstrated by the number of flashes possible per set. While alkaline batteries achieve around 150 flashes, rechargeable batteries only manage about half that number. Cheaper zinc-carbon batteries have an even lower capacity, managing only 50 flashes. These figures can, of course, differ from flash unit to flash unit, but their relative performance will roughly stay the same.

Things are completely different with flash recycling times. With fresh alkaline batteries, it may take a good nine seconds before the flash charge indicator lights up, but the flash unit will be ready for action after just five seconds when using fresh rechargeable batteries.

If you are looking for maximum flash output, you should wait a little longer after the flash charge completion indicator has lit up. The reason is that many units produce this signal when the condenser is only 75% charged as this gives better-sounding flash recycling times.

Automatic flash program

Setting: Set the camera to **P**, green program or one of the image zone shooting modes. Set the flash unit to A-TTL.

The simplest is the automatic flash program. Shutter speed and aperture will be selected automatically, so nothing can go wrong. It is the standard setting for almost every situation. In the interest of reliable results you should select this mode whenever you want to take simple flash shots without any hassle.

The flash sync speed is kept between 1/60sec and 1/125sec, which means that blur will be largely eliminated even in daylight

Remember that most EF zooms have a macro setting. This can open up the world of small things. These often pass us by unnoticed, but can now be consciously searched out. Set the longest focal length in order to limit the image section. Switch to manual focusing mode and set the shortest possible distance.

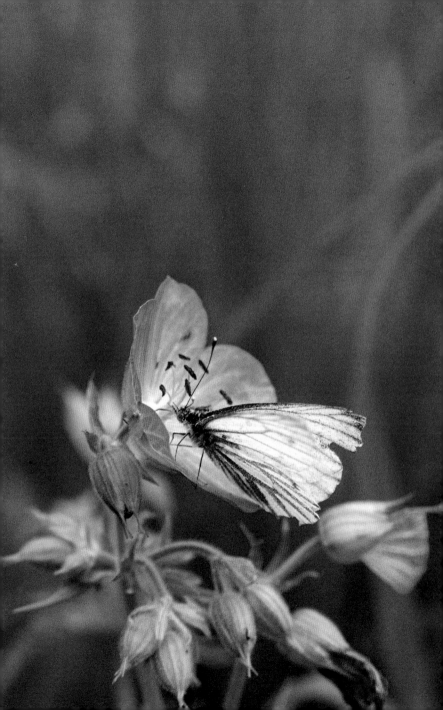

The automatic flash program is the right choice for standard subjects (not too bright or too dark); in this shot it provides the necessary light in order to make the armour glisten.

and with fill-in flash. In darkness there's little danger of camera shake anyway, because only the flash with a duration of between 1/700sec and 1/2000sec illuminates the scene.

This means that ultra-fast flash exposure times are possible when working close-up and with fully opened apertures. Here the amount of light required for the exposure is controlled via the flash duration, which becomes increasingly short as the shooting distance decreases and the aperture widens.

In this program option the aperture is controlled according to shooting distance and subject brightness. When the shutter is released, the light reflected from the film surface is measured, and the flash unit is switched off when sufficient light has been emitted.

Photography is all about recognizing subjects and light moods, and about making the most of these with the photographic means at your disposal. In this example the telephoto focal length makes the light reflections in the background blur into large circles of unsharpness, emphasizing the subject.

Flash aperture priority mode is useful for controlling the ratio of ambient and flash light more precisely.

This process also takes into account any daylight present, and uses the flash to fill in only if required. Canon calls this metering system A-TTL, Advanced Through The Lens, an advanced TTL metering system that takes into account ambient light.

Tip: There are different ways of coping with backlight. One is to spot meter from detail in the shade, and use the exposure lock. This increases the exposure of the whole subject, and the background will appear lighter, maybe even pure white. Fill-in flash produces a completely different effect. The contrast between foreground and background is balanced out in this way. The approach you choose depends on the result you prefer in a given situation.

If flash, ambient light and movement are to be combined, you should use second curtain sync, otherwise movements would look unnatural.

Flash aperture priority

Setting: Camera to **Av**, flash to A-TTL.

In this automatic flash program the photographer preselects an aperture, and the camera electronics will set a matching shutter speed. But watch out! The shutter speed set depends on the ambient light and may be anything between 1/125sec and a full 30 seconds. This means that this mode takes into account the proportion of ambient light, which may lead to unsharpness if you don't use a tripod.

With the camera handheld, this program can only be used for fill-in flash in bright daylight. But to be really safe, only use it when photographing from a tripod, especially as Canon's so-called A-TTL metering system will also give automatic fill-in flash in every case.

Flash shutter speed priority

Setting: Camera to **Tv**, flash unit to A-TTL.

In flash shutter speed priority the aperture is set automatically, depending on the shooting distance and the speed of the lens. The shutter speed can be preselected in a range from 30 seconds to 1/125sec, and this therefore allows a balanced exposure in terms of ambient and flash light. If you select shutter speeds faster than 1/125sec, the camera switches to the fastest possible sync speed of 1/125sec. The electronic system will set a suitable aperture to match the preselected aperture.

Second curtain sync

Setting: Custom function CF 2 to **1**.

Second curtain sync is a function that will only rarely be used in practice. It only creates a more natural effect with moving subjects which are to be rendered blurred by a long exposure, and sharp by using an additional burst of flash, In this case the blurred exposure

takes place first so it appears to trail behind the sharp flash-exposed image.

Flash exposure compensation

Setting: Press the button with the flash symbol, set to the left of the camera top-plate, just below the command dial. This allows you to input a flash exposure compensation of +/- 2EV, using the quick control dial on the back of the camera.

Flash exposure compensation allows the flash exposure to be adjusted by +/-2 EV. This is particularly useful with A-TTL flash metering, because it allows the balance between ambient and flash light to be finely adjusted.

Flash exposure metering is subject to the same laws as ambient light metering: predominantly light or dark subjects lead to incorrect exposures. In this case - many dark areas in the subject - flash exposure compensation would have helped.

But initially you should experiment without compensation in order to get to know how well A-TTL metering works. If you find the results too bright in the foreground, or too dark in the background, or vice versa, you can then intervene at a later date. The ambient light portion of the exposure is increased or decreased using the normal exposure compensation function, the proportion of flash light by the flash exposure compensation button.

You can then accurately achieve effects like the following, which already work quite well in automatic mode. With landscape photography you could expose a foreground subject like a blossom, stone or whatever using the flash, and deliberately underexpose the background slightly. The shutter speed needs to be selected so that the background, not covered by the flash, is underexposed by one to two stops.

A different effect will result by combining slower shutter speed and flash light to take shots of moving subjects. The flash will then combine sharp and blurred renditions of the same subject. Second curtain sync (CF 2 to **1**) is advisable to create a natural impression of movement. In order to achieve carefully measured movement blur, try the shutter speed set at between 1/15sec and 1/4sec for your first attempts. The ambient light measurement is used for the exposure, and the flash is set to give one to two stops less.

Manual flash photography

Setting: Command dial to **M**.

If you work with other manufacturers' flash units and a simple PC contact, then the EOS 100/Elan has to be operated manually. Here you need to ensure that the sync speed of 1/125sec is not exceeded, as the flash will not fire on faster speeds.

Manual exposure mode can also be useful for flash operation, for example when you are shooting with a studio flash set-up.

163

Generally system flash operation is, of course, possible with dedicated flash units from other manufacturers via SCA adaptors. This mode offers clear advantages as it comes with flash charge completion indicator, automatic switching to the sync speed and TTL metering. All this contributes to increased exposure reliability, as the risk of using incorrect settings is low.

But in special cases it can be quite useful to separate the flash unit from the system functions of the camera as much as possible, to achieve deliberate flash effects. Manual flash photography can be an advantage if you have to take quick shots of foreseeable events under difficult conditions. People outside at night are a good example, or freestanding subjects in a large hall. In automatic mode there's a danger of the foreground becoming overexposed. In manual mode the aperture can be accurately determined to match the shooting distance.

The fast winder setting offered by many flash units can also only be achieved with manual aperture control.

Using several flash units

Canon offers a cable system, consisting of adapter, distributor and connection cables, which allows up to four flash units to be used with TTL flash metering. In view of the fact that system flash units are not exactly cheap, and that it is not possible to control the output, you should carefully consider whether such expensive special cables are worth buying, or whether there are other, better ways of creating a lighting system of several flash units.

But buying one adapter and one cable is worth considering as it lets you use the Speedlite on an accessory track or off-camera. Off-camera TTL operation with two light sources can be useful, particularly for photography in the close-up and macro range.

A simple alternative to multiple flash use would be to shoot with smaller, cheaper manual flash units that you may still have from earlier days. Use the EOS 100/Elan in manual mode, but a few calculations and tests are necessary to make it really work.

Slave releases are useful in this context because they fire flash units without the need for cable connections and without a delay. They do this even across greater distances by using the impulse of

the camera flash unit and so do away with the need for yards of cables.

A small studio flash system and an external flash exposure meter are to be recommended for high demands and more frequent use.

Completing your camera system

The EOS models are already fairly comprehensively equipped cameras. For example, the camera already comes supplied a viewfinder cap. So the main accessories required are those that protect your equipment, like bags and cases, or allow you to broaden your horizons to tackle more specialist photographic situations, like a tripod which allows you to make long exposures.

Lens hood

Lens hoods are available in metal, rubber, or plastic, but they all do the same job. They protect the lens from unwanted side light, and thus reduce the amount of stray light entering the lens, which in turn avoids an unwanted reduction in image contrast.

Every fixed focal length should always have a lens hood. After all, it does no harm, but it might do a lot of good. I personally prefer the flexible, rubber or plastic types which can be folded back which saves space when the lens is stored in the camera bag.

Lens hoods are more difficult to make for zoom lenses, as the lens hood must never be allowed to become visible at the edge of the frame. If the lens hood perfectly suits a focal length of 70mm, and then the lens is zoomed to 28mm, then the angle of view is widened, and the edges of the lens hood become visible in the photograph as shadows. The answer is to use a lens hood made for the shortest focal length of the zoom range but this won't be very effective for longer focal lengths. At least the shorter focal lengths will then be well-protected from flare, and that's better than nothing. When using longer focal lengths towards bright sunlight you can always hold your hand against the sun so that the lens is shaded without your hand becoming visible. Incidentally, this isn't a bad idea with any focal length, even if you have a lens hood that perfectly suits a fixed focal length. In this way you can create your very own inexpensive optimum lens hood.

There are also adjustable lens hoods specifically for zoom lenses, but I question the practicality of constantly adjusting the lens hood. You run the risk that the most important photograph on the whole film will be vignetted (shadowed). The most elegant solution is a permanently integrated lens hood which adjusts with the focal length. Surely that should be a piece of cake for the people who've developed such interesting things as ultrasonic motors and autofocus systems. But they're just not doing it.

Please be careful with some of the EF zooms. When focal length is adjusted, the front element plus filter thread move into the lens tube and fitting a lens hood can block the zooming action.

Camera strap

A camera strap, such as the Op/tech Pro Camera strap is a very important accessory as it enables you to carry your EOS 100/Elan over the shoulder, around your neck or in your hand by means of the 'Pro Connectors' making a hand-carry strap. Either way, this enables you to shoot as you wish, but take care when carrying the camera in your hand, this is a way where the camera can suffer knocks and bruises!

Hung around your neck, or over your shoulder, you will find that with an Op/tech strap the camera is most comfortable to carry. The strap is unique in the way it absorbs the weight of camera and lens - no matter how big the lens you are using - and this will encourage you to take your camera with you at all times to get those once-in-a-lifetime shots that always seem to come along when you have left your camera at home.

Take care to read the instructions of how to fit any camera strap to your camera. Most are very easy, but once it is fitted you want to feel confident in knowing that your valuable camera is not going to work loose from the strap and end up in places you don't want it to be. If unsure, ask the camera store to fit the strap for you. It's all part of the service they offer.

Camera bag

Probably the most important accessory is a camera bag or hard-shell case. No photographer should be without one of the other. A hard-shell case is not as usual as a camera bag as these are used more often for transportation of equipment in planes, or used by the working professional photographer where a case like Kinetics/ Tundra do the job required. These cases will take a 2,000lb stacking load, are air-tight, dust-tight and water-tight, so for work in extreme conditions or where your equipment needs the highest level of protection, this is the case you should be looking at.

A camera bag is important in a different way. This is your every-day bag and as long as you keep in mind some 'technical' require-ments of a bag, you can then choose from the many brands available on the market. There is one bag that is very different however and this is a Domke bag. Domke bags are made of cotton canvas and therefore are naturally waterproof, but they have very little pad-ding. Their main feature is that they are very tough, very durable 'workhorses' that enable you to take pictures on the move and allow easy access to your equipment. On the other hand, almost every other brand of bag on the market has a high degree of padding and here you should look for certain features that will both protect and help you in storing your camera equipment in the bag.

Take your camera to the store when choosing a bag and make sure it's waterproof, has a non-slip shoulder strap, has enough outside pockets for all the bits and pieces you may want to carry and

Good bags have over-lapping flaps, easy ac-cess, non-slip shoulder straps and are made of a material that's water-proof.

168

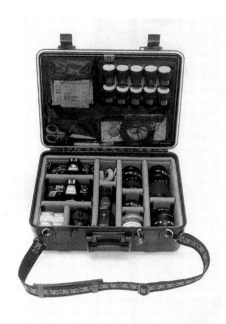

These tough Kinetica/Tundra cases are air-tight, dust-tight and water-tight. You can sit on them too.

then see that the internal layout of the bag is indeed suitable for your camera and accessories. One final matter, check the weight of the bag empty and when it's full of your equipment. Only then will you know you have the right bag for your purposes.

Magnifier S

The magnifier, which can be pushed onto the viewfinder eyepiece instead of the eye cup, produces an image of the viewfinder centre magnified by two-and-a-half times. This allows even more accurate manual focusing.

People with defective vision will be interested to know that the dioptric strength can be adjusted between -3 and +4. The magnifier can be flipped up to let you check the entire viewfinder image.

It is particularly useful for macro photography for accurately controlling autofocus, but is really designed for manual focusing. After all, once firmly mounted and aligned, the camera shouldn't be moved again.

Angle Finder

The Angle Finder B for the EOS 100/Elan ensures easy viewfinder access even in difficult situations. The viewfinder image is shown upright and the right way around. The finder has an adjustable dioptric setting from +2 to -4 dioptres and can be turned sideways by 90°. There is an 'A2' version which produces a reversed image. The angle finder is particularly useful if you take a lot of photographs with a microscope, repro stand or at ground level.

Dioptric adjustment lenses

Canon offers ten different adjustment lenses for the EOS 100/Elan, which are simply pushed over the viewfinder eyepiece. Short- or long-sighted people can use them to correct their vision over a range from +3 to -4 dioptres, so they can see the viewfinder image clearly without glasses. When glasses are removed, the eye can get closer to the eyepiece, and the viewfinder display is easier to see.

The viewfinder eyepiece is already adjusted to -1 dioptre, and you should take this into account when selecting an adjustment lens. It's best to choose the optimum correction lens directly in the shop, where you can try different variations. The adjustment lenses are suitable for short- and long-sightedness, but cannot take other visual defects like astigmatism into account.

Remote controller

You should resort to the remote controller when it is important that the camera shutter is released quickly and without vibration. If you take a lot of tripod shots you should also consider it, since it prevents vibration. Compared to a conventional cable release this controller releases more easily and more accurately, as no physical effort is required to push it down.

It works up to five metres away, and can be set to give a time delay of two seconds before the camera shutter is released. If the controller is constantly pressed, shots are taken at two-second intervals.

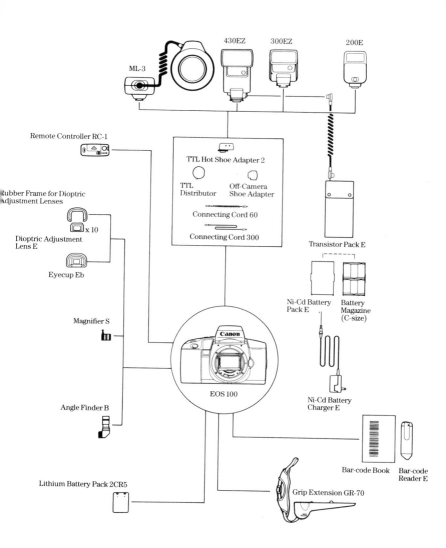

ML-3

430EZ

300EZ

200E

Remote Controller RC-1

TTL Hot Shoe Adapter 2

TTL Distributor Off-Camera Shoe Adapter

Connecting Cord 60

Connecting Cord 300

Transistor Pack E

Rubber Frame for Dioptric Adjustment Lenses

x 10

Dioptric Adjustment Lens E

Eyecup Eb

Ni-Cd Battery Pack E Battery Magazine (C-size)

Magnifier S

Canon

EOS 100

Ni-Cd Battery Charger E

Angle Finder B

Bar-code Book Bar-code Reader E

Lithium Battery Pack 2CR5

Grip Extension GR-70

Tripod

Sooner or later you will also need a tripod, because you will soon realize that flash tends to destroy the very mood you wanted to capture. And you can't make long exposures without a tripod.

A tripod also offers advantages for shots where you've got plenty of time and when you're staying in one place. Every subject can be shot a lot more carefully from a tripod, because you can adjust the EOS 100/Elan and fix it in position down to the last millimetre. If you have the camera in your hand it's always a more wobbly affair. This is why a tripod is useful for carefully composed shots, even when handheld photography is theoretically possible.

The crucial question when choosing a tripod is should it be light and portable, or heavy and sturdy? Both at the same time is impossible, and compromise is always necessary. When starting out, I would recommend a light compact tripod that you can take

Use a particularly sturdy tripod at home, and a smaller, lighter tripod when you're on the move. This solution is better than using one tripod for every occasion - one that is light enough to be carried around, but no longer provides maximum sturdiness.

172

anywhere - perhaps even just a small table tripod. Normally you won't use a tripod often enough to need a sturdy, heavier one. So a lighter version is better, because you can always keep it with you. If you later need to take a lot of tripod shot, and miss the necessary sturdiness, then that's the time to find a really sturdy version that's heavy. The worst thing of all is a interim solution, which is no longer light, nor completely solid.

I particularly want to draw your attention to monopods, which, unfortunately, have been rather neglected and are offered by very few manufacturers nowadays. A monopod is great for telephoto photography and is such a good camera support that, compared to handheld shooting, you can shoot a further two shutter speed steps slower without risk of camera shake. The EOS 100/Elan remains almost as mobile as it is when handheld, but it is so well supported that sharp shots are even possible when the green **P** has started flashing in the viewfinder. So if you frequently reach the camera shake zone but can't afford, or don't want, the fast EF 300mm,f/2.8 L or another fast focal length, then a monopod may provide a far cheaper solution.

It doesn't, of course, represent a full replacement for a faster lens, as the shutter speed will always be slower under the same shooting conditions. You may remember the aperture range f/2.0, f/2.8, f/4.0, f/5.6, f/8 and so on. According to this, the EF 300mm,f/2.8 is four times as fast as the EF 100-300mm,f/5.6. At the same brightness and at maximum aperture this would mean a shutter speed of, for example, 1/125sec with the zoom and 1/500sec with the fixed focal length. So the fixed focal length in this example will always be two steps faster. In sports photography, where the fastest possible shutter speeds are important to freeze fast movement, the photographer using a zoom lens and monopod won't run any risk of camera shake, but the tennis player, footballer or whatever will still be reproduced unsharp.

Equipment suggestions

Thanks to zoom lenses, putting together a system to use in almost all situations isn't a problem. A small outfit might look like this - EOS 100/Elan (of course!), any one zoom lens, camera bag, cleaning set, tripod, UV filters to protect every lens, lens hood and a flash unit.

173

With the EOS 100/Elan you can do without an additional flash unit, as the integral unit will initially cope with any emergencies.

The first important accessory is a lens brush with a small bellows, lens tissues and compressed air for cleaning. A basic filter set consists of a filter holder, adapter rings for the filter threads of all your lenses, a polarizing filter, and one or two effect filters to give you a taste.

In terms of film, I would recommend that you start off with two to three films, one in each of the low, medium and high speed categories. This way you will get to know how grainy and sharp they are, and how they suit different subjects and applications. Try ISO 50/18°, 100/21° and 1000/31° films, ideally a set in black-and-white, colour negative and slide emulsion, to let you get to know all the different possibilities available. Later on keep a small stock of your favourite category, but keep fast and slow emulsions to hand for special shooting situations.

A more comprehensive set of equipment should include two lenses like the EF 28-70mm,f/3.5-4.5 and EF 70-200mm,f/4.0, or a similar combination covering the wide-angle to telephoto range. Equipped like this, you will be able to cover almost all shooting situations satisfactorily .

The macro setting available on most EF zoom lenses will initially be quite sufficient for close-up shots. Depending on the lens, this allows frame-filling shots of subjects up to a size of around 20 to 40 centimetres. The 50mm,f/2.5 Macro lens is a specialist lens for people who do a lot of close-up work and at the same time make particularly high demands in terms of sharpness, contrast and image flatness. Currently this lens is the only way to use the EOS 100/Elan at a macro ratio of 1:1.

Right, now you're fully equipped. If you have different ambitions, and want to take up wide-angle photography for example, then you should go from the general to the more specialized. Don't go buying the 15mm Fisheye just because you've seen a great shot taken with one. It's better to consider a focal length of 28mm or 24mm because it's more likely to allow you to cover many more possibilities. The Fisheye can come later, when you've turned into a complete 'wide-angle freak'.

The same goes for all your equipment - extend it carefully. Beginners in particular can otherwise be totally overwhelmed by

the many possibilities on offer. And instead of taking good photographs, you'll end up despairing about all the alternatives, because you can't get to grips with them. It's best to start off with a moderate zoom and get to know it, than it is to have lots of lenses and not know which one to use at any one time.

Finally, when you're thinking about which bits of equipment are going to be the best, remember that you bought the EOS 100/Elan in order to take lots of good photographs. And to achieve that, it's not the equipment that matters, but the person behind the camera.

ACCESSORIES WELL WORTH LOOKING AT!

OP/TECH

The world's most comfortable cameras, bag and tripod straps (binoculars too). Op/tech has a built-in weight reduction system that makes equipment feel 50% lighter and 100% more comfortable. From the famous 'Pro-Camera Strap' to the 'Bag Strap' and the 'Tripod Strap', the style, colours and comfort which along with the non-slip grip, ensure that you have a wonderful combination of comfort and safety.

DOMKE

The favoured bag of the world's photo press. Designed to be used and made from all-natural materials, Domke has grown to become known as the 'workhorse' of all camera bags for it's toughness and durability. Made from 100% soft, supple cotton canvas which molds around its contents and hugs your body. Nature's perfect material is naturally water-resistant and will not harm either equipment or clothing. A non-slip shoulder strap is an added feature of all Domke bags.

LUMIQUEST

For any portable flashgun that has a bounce head, Lumiquest is an accessory system that has a place in everybody's camera bag. Not just to reduce 'red-eye', but from the simple 'Pocket Bounce' through to the 'Softbox', added diffusion for flash portrait or close-up's of still life can be achieved while at the same time Metallic Inserts in silver will give spectacular highlights and in gold, a warm sunset tone. Snoots and Barndoors are part of the system for the creative flash photographer.

STROBOFRAME

The perfect partner for all 'off-camera' flash users. 35mm or Medium Format there is a Stroboframe bracket suitable for you. Getting a flashgun off a camera is vital for creative and studio-like effects. Camera mounted or side mounted flash will simply not give you the effects you are looking for. Stroboframe will. Also in the range is the famous 'LEPP 11' macro flash bracket that provides full creative lighting control when you need to get close. To make it easy to get the camera on and off a bracket, the 'QRC' Camera Auto Quick Release is a welcome accessory.

KINETICS

The tough hard-shell case (known as Tundra Sea King in the USA) that is favoured by all those who travel and have a need to fully protect valuable camera or electronic equipment. Made of hard industrial plastic that will withstand the rigours of travel, with the added advantage of being airtight, dustight and watertight when locked down. With a Kinetics case you can now enjoy taking your valuable equipment wherever you want in the knowledge that it will be safe from impact, dust and moisture.

JERSEY PHOTOGRAPHIC MUSEUM

OVER 1000 CAMERAS AND PHOTOGRAPHIC ACCESSORIES
ON SHOW FROM 1850 TO PRESENT DAY
EXHIBITION OF PHOTOGRAPHS IN THE GALLERY
CONSTANTLY CHANGING
OPEN 0900-1700 HOURS MONDAY-FRIDAY.
0900-1200 HOURS SATURDAY
CLOSED SUNDAY AND PUBLIC HOLIDAYS

THE PHOTOGRAPHIC MUSEUM IS LOCATED IN THE CHANNEL
ISLANDS BETWEEN ENGLAND AND FRANCE IN THE LARGE
**HOTEL DE FRANCE, CONFERENCE & LEISURE COMPLEX
ST. SAVIOUR'S ROAD, ST. HELIER, JERSEY, C.I. JE4 8WZ
TEL. 0534 73102 FAX 0534 35354**

For a complete catalogue of the many Hove Foto Books and User's Guides for Modern Cameras write to:-

Worldwide Distribution: **Newpro (UK)**
 Old Sawmills Road
 Faringdon, Oxon
 SN7 7DS

 Tel: 0367 242411
 Fax: 0367 241124

In USA: **The Saunders Group**
 21 Jet View Drive
 Rochester
 NY 14624-4996, USA

 Fax: 716-328-5078

In Canada: **Amplis Foto Inc.**
 22 Telson Road
 Markham, Ontario, L3R 1E5

 Fax: (416) 477-2502

Or from the Publishers: **Hove Foto Books**
 Jersey Photographic Museum
 Hotel de France
 St. Saviour's Road, St. Helier
 Jersey, C.I. JE4 8WZ

 Tel: (0534) 73102
 Fax: (0534) 35354